IMAGES
of America

DELANO AREA
1776–1930

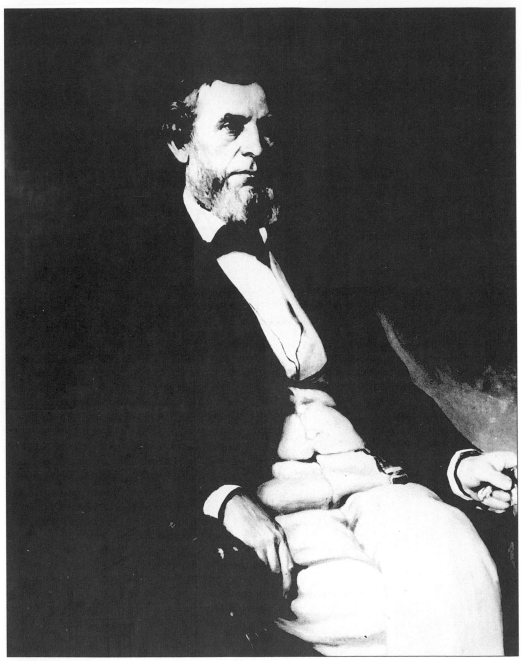

Pictured is Columbus Delano, Secretary of Interior, 1870–1875.

IMAGES
of America

DELANO AREA
1776–1930

Dorothy Kasiner
Delano Historical Society

ARCADIA

Published by Arcadia Publishing,
an imprint of Tempus Publishing, Inc.
2 Cumberland Street
Charleston, SC 29401

Printed in Great Britain.

Library of Congress Catalog Card Number: Applied for.

For all general information contact Arcadia Publishing at:
Telephone 843-853-2070
Fax 843-853-0044
E-Mail arcadia@charleston.net

For customer service and orders:
Toll-Free 1-888-313-BOOK

Visit us on the internet at http://www.arcadiaimages.com

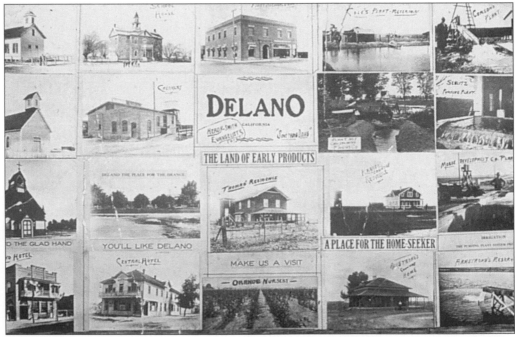

A postcard from 1912 depicts Delano's diversity.

CONTENTS

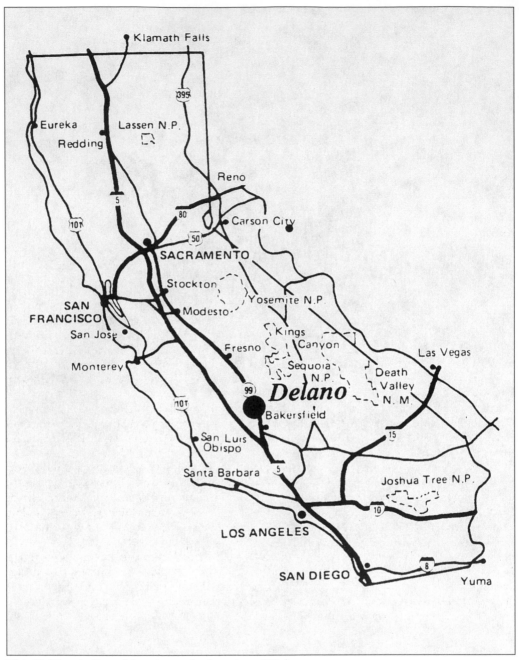

This California State Map shows the location of Delano.

INTRODUCTION

Padre Francisco Garces's discovery of the lush San Joaquin Valley in 1776 and his noted baptism of the first Yokut child opened up a new land. As word spread of the abundant fowl, bear, deer, elk, horses, tall grasses, and water, explorers like Jededia Strong Smith followed Father Garces's trail into the area. Kit Carson came through in 1830, followed by John C. Fremont with his surveying party in 1844. In 1852 the first known settlers, Tom and Mary Clark settled at Coyote Springs to raise cattle.

The pioneering spirit was contagious as sheep and cattlemen coveted the foothill grasses to build empires. Gold was discovered on Upper Rag Gulch in 1853, spurring on the settlement of the area. However, it was the Southern Pacific Railroad and the depression of 1873 that were the turning points in establishing Delano.

The railroad stopped laying track for one year at the site of Delano, known as end of track. Ranchers, farmers, and miners realizing the advantage of shipping from Delano, as opposed to driving or transporting their product to San Francisco, contributed to the boom town. Businesses began to serve the growing populace as farming began to develop in the surrounding countryside. Nearby communities sprang into being, lending support to the development of Delano.

This book attempts to show you, the reader, a picture of Delano, its diverse growth and evolution, coupled with the pioneering spirit brought by the settlers who farmed, mined, and developed the area from 1776-1930. This pioneering spirit was driven by people from ethnic groups from across the world—Basque, French, Yugoslavian, Spanish, Mexican, Yokut, Russian, and others fleeing to obtain a better life—and their story of building Delano is unique and inspirational.

ACKNOWLEDGMENTS

In 1961 a group of concerned citizens met at a local elementary school to organize the Delano Historical Society in an effort to preserve the area's pioneering spirit. The Historical Society has gathered local family histories, photographs, artifacts, and historical buildings and placed them in an historical park accessible to the public. Heritage Park is managed and operated by the Delano Historical Society.

The Plow is a quarterly publication that publishes articles and information related to Delano's heritage. It is the goal of the Delano Historical Society to make available local history for future generations.

My major sources of information and photographs were the archives of Heritage Park and the Delano Historical Society's publications, *Delano: A Land of Promise* and *Where the Railroad Ended*.

I wish to give thanks to the staff at Heritage Park for their assistance in the research, organization, and typing of the information in order to meet the contractual deadline.

"Our history is the mirror which focuses the present and illuminates the future."

One

EARLY HISTORY

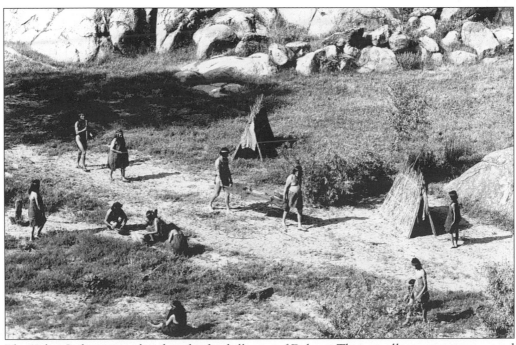

The Yokut Indians once lived in the foothills east of Delano. Their small encampments spread across the rolling terrain and they constructed their nomadic homes of tules and wood. During the summer season the natives moved following the receding shoreline of the Tule Lake and returned to the foothills as winter approached. (Simulation/Delano Community Theatre.)

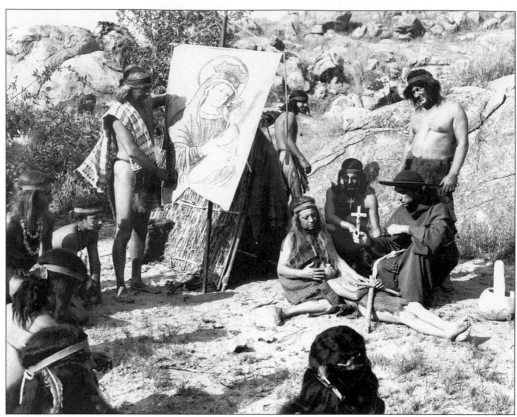

A reenactment of Padre Francisco Garces from the Spanish (Catholic) Mission of San Xaviar del Bac in Sonora, Mexico, giving the last sacrament to a small Indian boy at a site 16 miles northeast of Delano. Father Garces performed the first Christian baptism recorded in the San Joaquin Valley. (Simulation/Delano Community Theatre.)

This photograph shows the Yokut burial grounds located east of the Baptismal site where Padre Francisco Garces first made contact with the Yokuts in the foothills near Delano. The area surrounding the burial grounds has not changed much over the centuries. With permission from local ranchers, one may visit the historic sites.

Father Francisco Garces was the first known white man to enter the San Joaquin Valley through Oak Creek Pass. Traveling through the foothills, he crossed Poso Creek reaching Woody. Upon encountering natives in the foothills, he acquired a guide, who led him to White River were he found a village of Yokuts whom he introduced to Christianity.

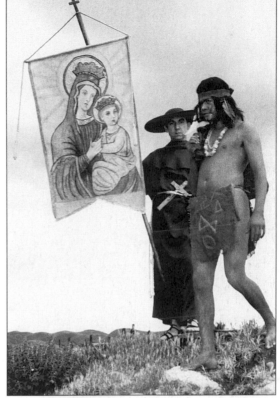

A small stream runs through this box canyon at the site where Father Garces baptized the first Indian child in 1776. Rock paintings and potholes on the canyon walls indicated that the Yokuts frequently visited the area, making their simple nomadic encampments.

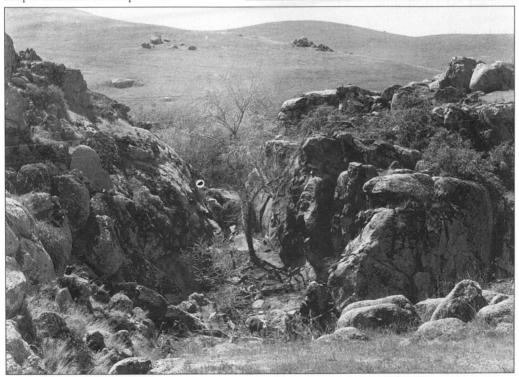

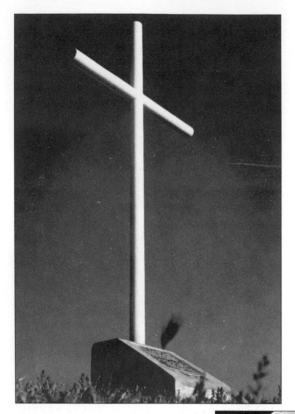

A 20-foot white cross was erected to mark the site of the first Christian Baptism in the San Joaquin Valley. It is located on Garces Highway (named for the Franciscan padre) across Highway 65, in the rolling foothills 16 miles east of Delano.

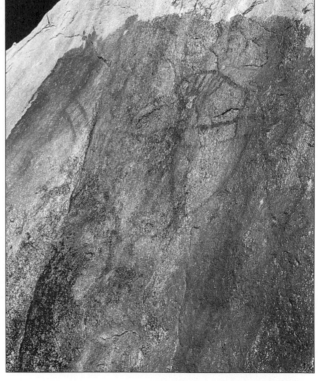

Pictured here is a sample of the rock paintings found on a box canyon wall. Throughout the canyons and valleys rimming the San Joaquin Valley, one can find simple rock paintings and lithographs made by the nomadic tribes of Yokuts, who once numbered in the thousands in the eastern foothills of the San Joaquin Valley.

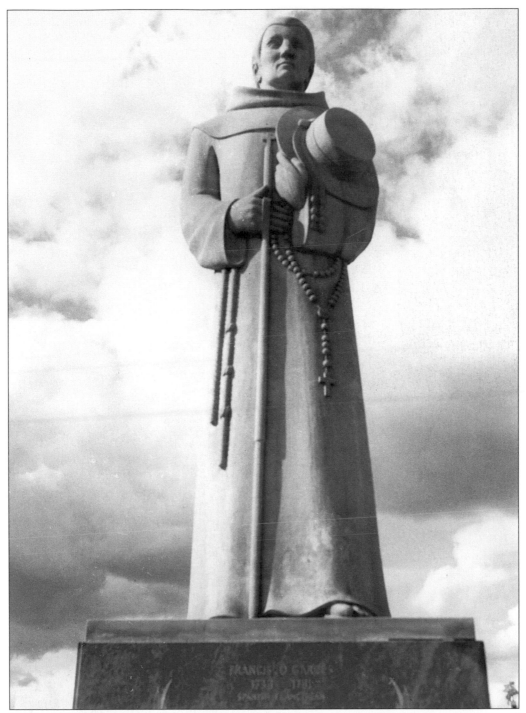

In "the Circle," located on North Chester Avenue in downtown Bakersfield, a sculpture of Padre Francisco Garces was erected to commemorate the first white man to enter the San Joaquin Valley. From atop a hill, Father Garces is able to gaze out across the southern San Joaquin Valley and view the barren expanse of sage brush, creek beds, and trees trailing off into the horizon.

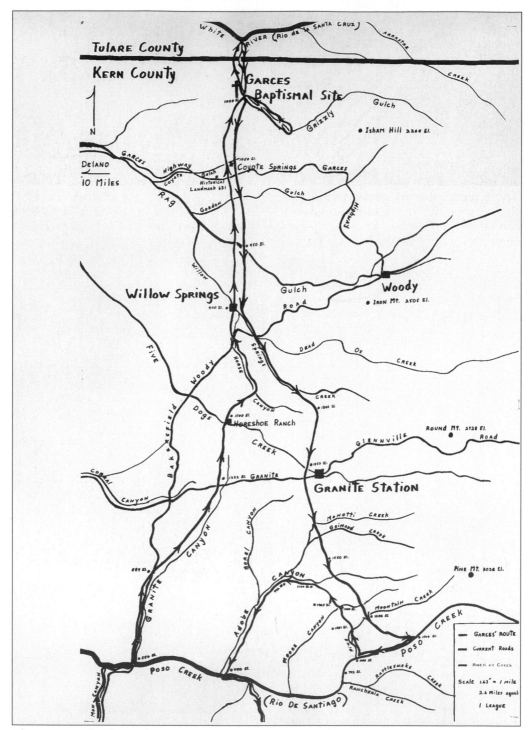

This map marks the path Padre Francisco Garces traveled as he crossed the mountains near Tehachapi, the Kern River, and Posa Creek before reaching White River, where he aided the Yokuts.

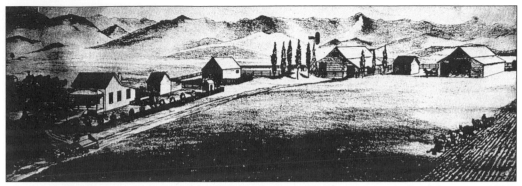

The Spangler Ranch, located two miles northeast of Richgove, is pictured here in 1890. Records show that the Spanglers moved from the Hanford area to a homestead in the foothills east of Delano in about 1881. The Spangler brothers were instrumental in the planning and construction of the Rag Gulch Dam for the purpose of irrigation.

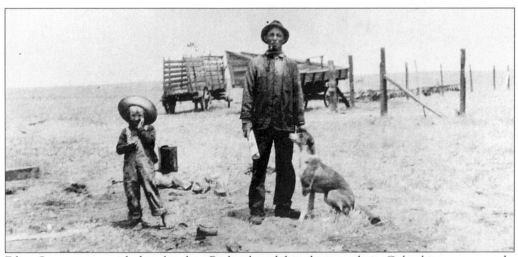

Edna Scott poses with her brother Richard and his dog on their Columbine area ranch, northeast of Delano, in 1914. The family moved into the Delano area on November 9, 1906, leasing part of the Quinn property to engage in farming. Dry land farming was common due to the lack of irrigation systems. The farmer had to depend on the yearly rainfall for his crops.

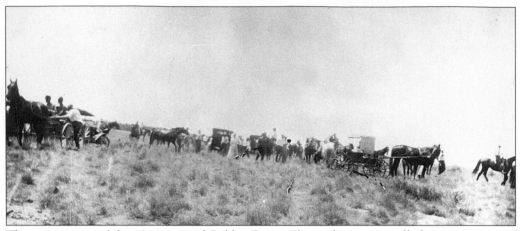

This is a picture of the 1914 Annual Rabbit Drive. The tradition originally began as a way of ridding the area of the over-population of jack rabbits, which had become pests on the open range. As with any enterprise, however, the pioneering spirit emerged, and soon William J. Browning had developed a new business (see below).

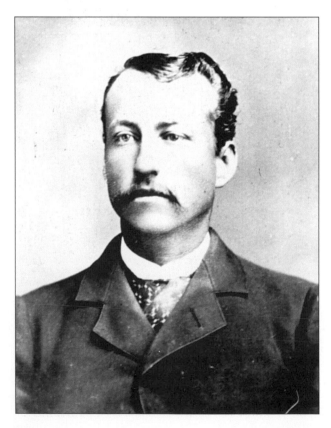

William J. Browning, pictured here on his wedding day in 1885, became known as the "Jack Rabbit King." He offered a bounty for each rabbit captured and shipped the furry creatures to hotels and chophouses along the Pacific Coast.

This photograph of Emma Browning, wife of William J. Browning, shows her in her wedding dress on her 18th birthday in 1885. She was a member of a prominent pioneer family, the Linders of Tulare, California.

Jack rabbits herded into a fenced area awaiting shipping crates as local ranchers and farmers view the day's catch. The rabbits posed competition for the crops and grasses in the area. The capture and shipping of rabbits to eateries in California became a profitable business.

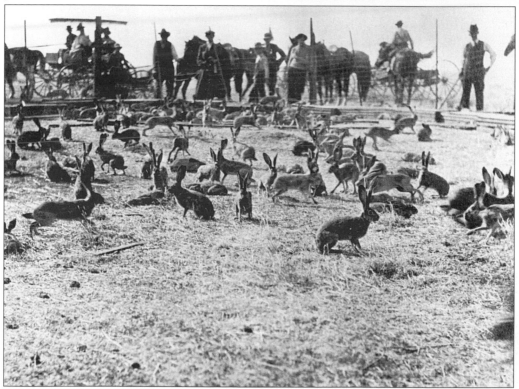

We the undersigned, wishing to rid the country of an increasing pest, do each hereby subscribe a small amount of money to buy four miles of rabbit fencing to be used as wings which will belong to and be used by the people of Northern Kern Co. and Southern Tulare Co.

Two miles of this fencing will be sold after the first big drive of Oct. 6, 1908, and the proceeds used to pay the expense and incidentals of the drive.

The remaining two miles to be used at any time in the future by the people of Delano, Mc Farland or Hamlin districts when required for the common good.

Name		Amount		
Chas. W. Ralls	Pd.	1 00		
	Pd.	2 00		
O. O. Robertson	Pd.	5 00		
J. A. Robertson	Pd.	1 00		
Bert Lochridge		5 00		
Chas. Ried	Pd.	2 00		
C. O.	Pd.	1 00		
J. W. Decarpo	Pd.	1 00		
M. L. Eustis	Pd.	1 00		
Geo. Duncan		2 00		
Chas. Aylmore	Pd.	1 00		
Earnest Allen		1 00		
	Pd.	1 00		
Ey. Kramer	Pd.	1 00		
		1 00		
Cox	Pd.	2 00		
Hinick	Pd.	1 00		
S. H. Morse	Pd.	5 00		
R. E. Rowe	Pd.	50		
	Pd.			
Peres J. Walsh	Pd.	1 00		
John Mc Millen	Pd.	1 00		
P. J. Green	Pd.	1 00		
J. C. Hutzy	Pd.	1 50		
orange Home Improvement assn.	Pd.	5 00		
Jim Panero	Pd.	1 00		
Frank Berk	Pd.	1 00		
C. Berrier	Pd.	50		
Union Lumber Co.	Pd.	7 50	7	50
A. L. Smith	Pd.	1 00	4	50
Everett Timmons	Pd.	1 00		
John Yoakum	Pd.	4 00	69	65
Ben Thomas	Pd.	2 50		
W. C. Brunner	Pd.	1 00		
W. F. Laird	Pd.	5 00		

This agreement was used to pay the bounty placed on the heads of jack rabbits. The jack rabbit drives were two-fold: it gave businesses an inexpensive meat to serve to clients and assisted the farmers and ranchers in successful crop production.

The Weaver Ranch, built in 1887 by Charles A. Weaver for his family, was located on Girard Street, between Twentieth Avenue and County Line Road. It was the first Victorian-style house to be built in Delano. The Weaver House, designated as a landmark, has been moved into Delano's Heritage Park.

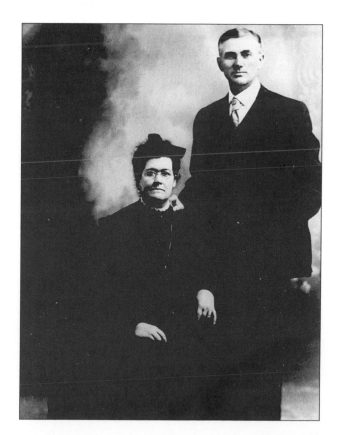

Harriet Emily and Charles Amos Weaver pose in this 1908 photograph. Charles Weaver maintained a hardware and plumbing shop in Delano, while operating as a grain grower and buyer in the area. His hardware store was the first to be opened in the Delano area.

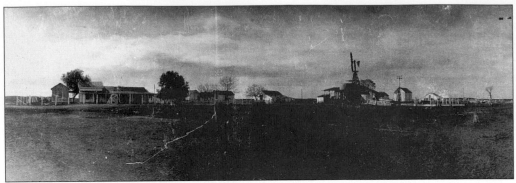

The Quinn Ranch in the Rag Gulch foothill area east of Delano had the only water well for miles around. It was not uncommon for travelers to stop by the Quinn Ranch on their way through the valley between Los Angeles and San Francisco.

In 1872, pioneer rancher Harry Quinn established an extensive sheep business with up to 28,000 head on 22,000 acres. Quinn expanded his ranching to include cattle and dry land grain farming. He was a prominent figure in the Delano/Porterville area.

Katie Robertson married Harry Quinn on December 15, 1886, and bore him seven children —four boys and three girls. She maintained her home, raised her children, and aided her husband in his endeavors.

The Quinn School appears here in 1904. As the Quinn family increased and the ranch expanded, education became essential for the ranch children, so a school was established to educate the Quinn children, their employees' children, and children from neighboring ranches.

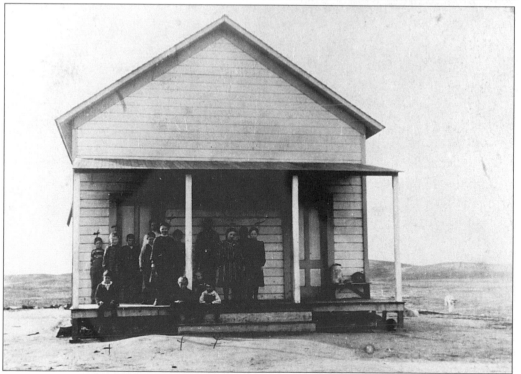

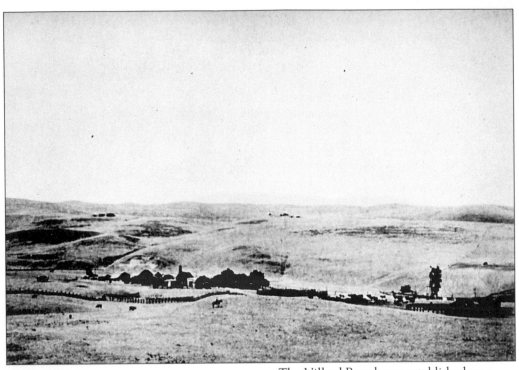

The Villard Ranch was established on a homestead at Rag Gulch in 1881. Sheep grazed the range until Ambroise Villard turned to cattle in 1903, at which time the ranch increased in size to thousands of acres. The present-day Villard Cattle Company is still headquartered on the original homestead.

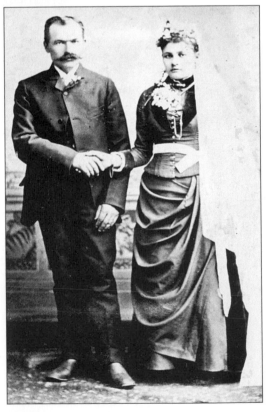

Ambroise Villard married Eugenia Mane Faure, a native of France, on January 31, 1887. The family descendants still operate and maintain the Villard Ranching business in the Delano / Porterville area.

Two

END OF THE TRACK— BOOM TOWN

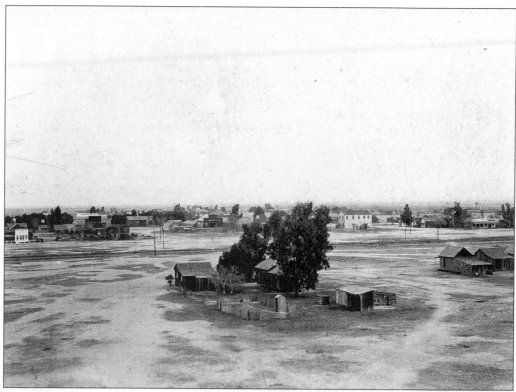

In this view of the city of Delano in 1905, one can see that the Southern Pacific Railroad ran north and south through the center of town. As the community developed, it grew parallel to the tracks. The Odd Fellow's two-story white building is visible in the background to the right.

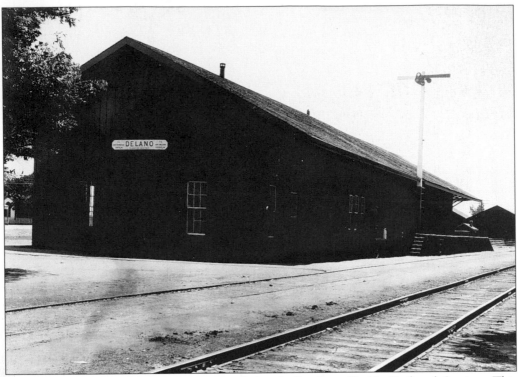

Passengers arrived and boarded trains at Delano's Southern Pacific Railroad Station. This photograph was taken about 1920. Freight was handled and shipped south from Delano, first to Bakersfield, then to Los Angeles or across the Tehachapi Mountains to the eastern markets. It was not uncommon for shipments to go north by rail to San Francisco and its seaports.

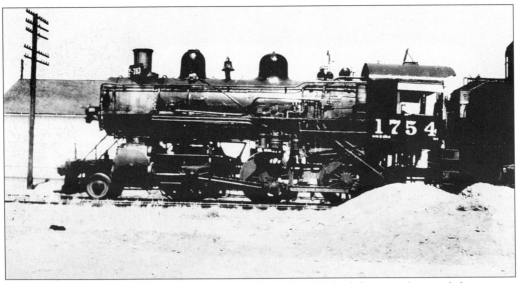

In 1873, Delano became a boom town when the railroad halted due to a financial depression. Pictured here is Engine #1754, used to pull the carloads of sheep, cattle, or produce from nearby farms and ranches to their intended destinations. Thousands of dollars of gold was brought from the mines to be shipped out of Delano.

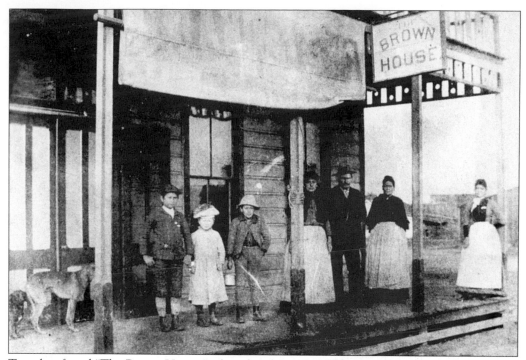

Travelers found "The Brown House," a boarding house located across from the railroad station, a comfort while waiting for the train. Edward Shilling, Hortensia Mandis, Ulece Mandis, Frances Mandis, Sam Shilling, Rita Shilling, and Alenna "Nellie" Mandis are pictured in this photograph taken around 1889–90.

Adrian Mandis, known as Delano's first millionaire between 1878–1888, was the proprietor of several hotels, the city's first livery stable, and a saloon. He also operated the largest sheep shearing corrals in California. Born in 1838 in Mezin, France, he came to Delano in 1875 from Snelling, California, where he had managed a hotel.

In 1875, Frances Saiz married Adrian Mandis. On January 20, 1877, she gave birth to Margarita, the first French child born in Delano. She is pictured here with Charles Urban Mandis, the eldest of her five children.

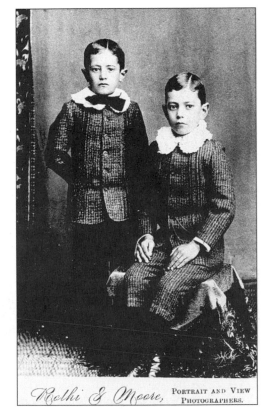

This photograph of Adrian and Frances Mandis's two sons, Ulece Mandis (age seven) and Charles Urban Mandis (age nine), was taken July 3, 1888. Mrs. Mandis traveled extensively with her children to San Francisco and on occasion returned to France.

Rothi & Moore, PORTRAIT AND VIEW PHOTOGRAPHERS.

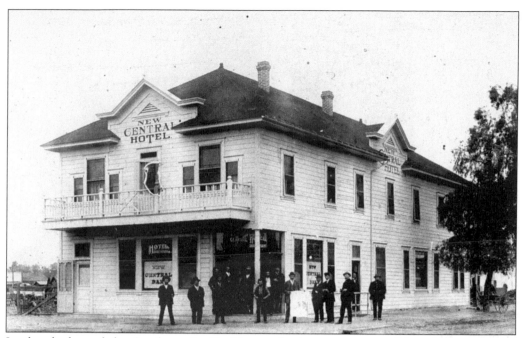

In the shadow of the Southern Pacific Depot, the luxury two-story "New Central Hotel" became the place to dine in Delano. It boasted an elegant dinning hall and bar with the choicest wines, liquors, and brandies with reasonable rates. This photo was taken in 1890.

The Mitchell and Dorsey Blacksmith Shop was located on the northeast corner of Twelfth Avenue and High Streets. The shop built in 1887 served the local ranchers, farmers, and citizens. This 1901 photograph shows Columbus Dorse, N.R. Mitchell, and Jimmy Martin.

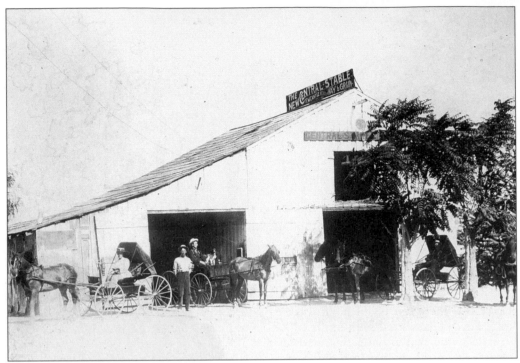

In 1909, F.W. Cantleberry operated "The New Central Livery and Feed Stable," offering the best horses, rigs, and service at reasonable rates. One could rent a rig to tour the countryside or horses to help with the plowing in the fields.

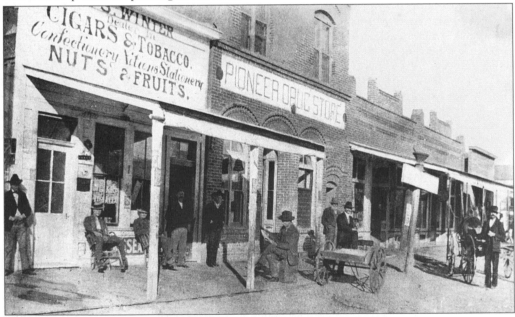

Pictured is Delano's drugstore and post office during 1894 in the 1000 block of Main Street (west side of the street). Standing to the far left is Roy "Butch" Masters, seated is Will Marshall, Mr. Bailey, Winfield Scott, James "Bud" Vernon, reading a paper, unidentified, unidentified, and E.H. Ramsay by the mail cart.

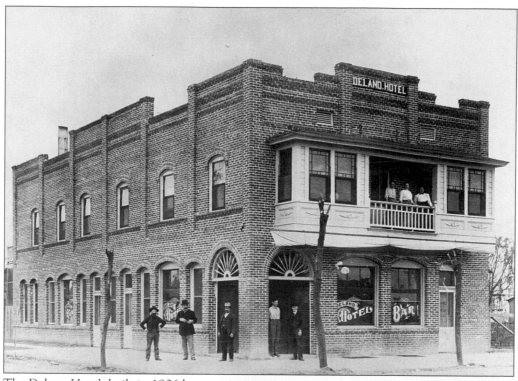

The Delano Hotel, built in 1906 by the Borel family, still stands at the corner of High Street and Twelfth Avenue. It often served as a haven for travelers passing through Delano on old Highway 99. During the late 1800s and early 1900s, it offered shelter to a number of famous men. The Dalton brothers, one noted gang of outlaws, visited the hotel before holding up a train 15 miles north of Delano.

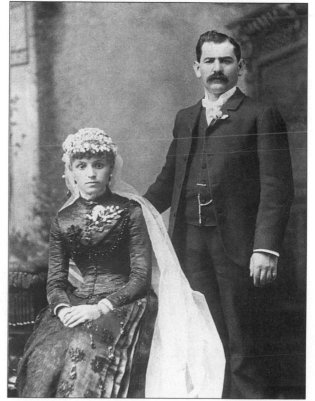

Auguste Borel moved to the Delano area in 1884 entering the sheep business. On July 14, 1887, Auguste and Marie Labarthe Borel married in Delano. They purchased an existing hotel in 1903, which was destroyed by fire. The Borels established and operated a restaurant until their new hotel (pictured above) was completed in 1906.

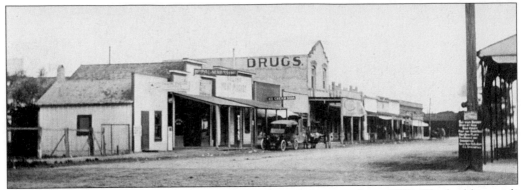

This is Delano's Main Street looking north from Tenth Avenue about 1907. The building with the sign "Drugs" (center) was Ramsey Drugs, which was destroyed in the 1915 fire. The oldest brick building in Delano was built in 1891 on the northeast corner of Main Street.

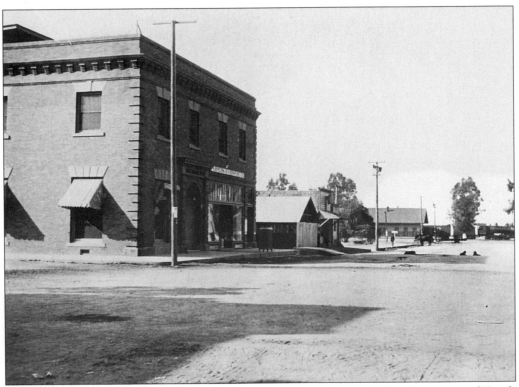

The Swan Insurance building appears in this 1911 view looking west from the corner of Tenth Avenue. To the right in the background, a train had just pulled into the railway station to deposit passengers and freight before reloading for its trip north.

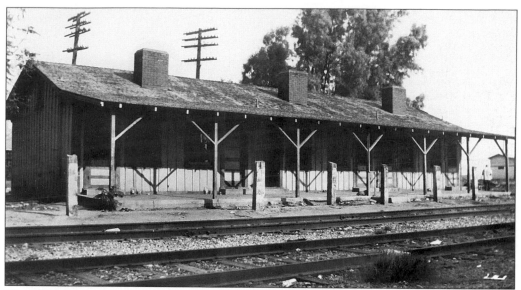

The Southern Pacific Railroad Section House was used by railroad employees. It faces east on the west side of the S.P. tracts between Ninth and Tenth Avenues. Delano's importance as a shipping center increased with the shipping of a variety of freight and livestock, increasing the need for railroad personnel housing.

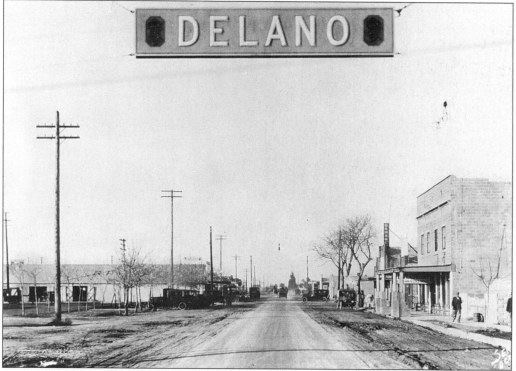

Old Highway 99 (Front Street/High Street) ran through Delano. The long white building visible on the left is Bowhay's Garage, located at Eleventh Avenue and High Street. Valencia's brick building, pictured on the right, was built in 1914. This 1925 photo was taken at Tenth Avenue and High Street looking north.

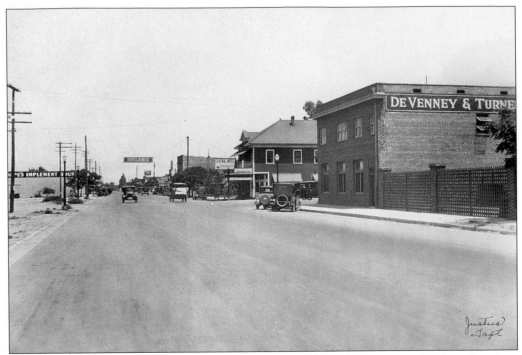

A 1929 photo of Old Highway 99 (High Street) located through the center of Delano (north to south) ran parallel to the S.P.R.R. A.H. Karpe Implement House, pictured on the left, was managed by William J. Taylor. The brick building in the center was owned by Nash Valencia. The Central Hotel, visible center right, stood on the corner of 10th and Front Streets (High Street). The offices of Devenney & Turner are in the foreground to the right with Devenney's living quarters on the second floor.

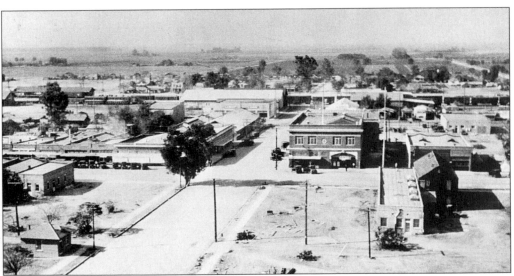

This 1925 photograph was taken from the top of the Delano Water Tower in the center of the business district, looking west toward the Southern Pacific Railroad. After the fire of 1915, the City of Delano adopted a definite plan for the internal development of city streets.

Columbus Delano, Secretary of Interior 1870–1875, and the uncle of President Franklin Delano Roosevelt, was in office when the Southern Pacific Railroad began its expansion through the San Joaquin Valley. Due to the depression of 1873, the railroad halted laying track. The end of track received its name from the Secretary of Interior, and thus, Delano was christened.

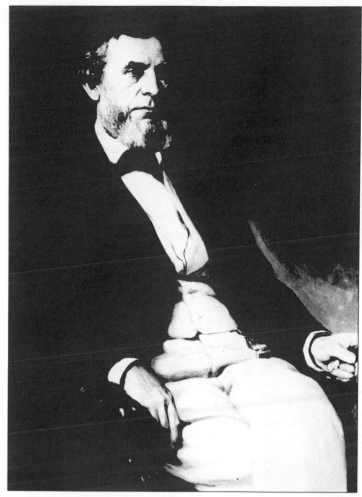

The Masonic Temple, located on the northwest corner of Main Street and Eleventh Avenue, was constructed in 1915. This 1917 photograph reinforces the pioneering spirit that conceived Delano. Ramsey's Drug Store (center) was rebuilt on the corner of Eleventh Avenue (southwest corner) replacing his two-story building destroyed in 1915 by fire.

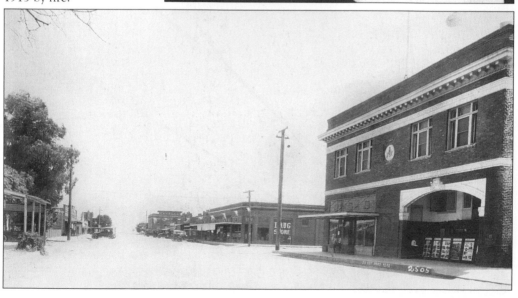

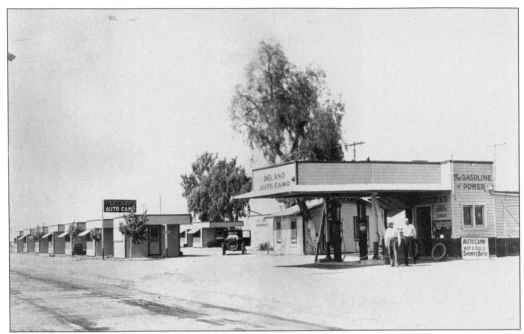

In 1920 the Delano Auto Camp was located on old Highway 99 (north) at Eighteenth Avenue. The camp became a temporary home for migrants who fled the "Dust Bowl" of the Midwest with dreams of the "Golden Promise Land." The buildings later served as housing for Mexican immigrants who worked the fields in the area. The camp was demolished in 1997.

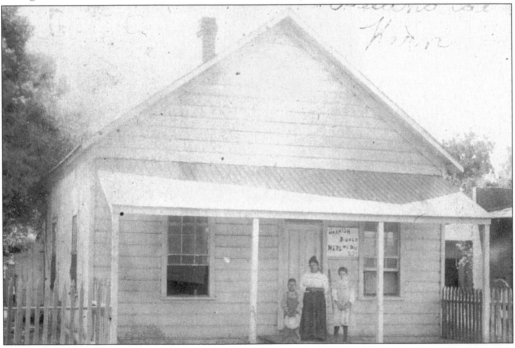

Frank Valencia, Pascuala Valencia, and Susie Valencia stand on the porch of the Spanish Kitchen in the early 1890s at Eleventh Avenue and Glenwood Street. For a number of years, Pascuala Valencia was famous throughout Kern County for her tamales.

Three
PIONEER
FARMING/RANCHING

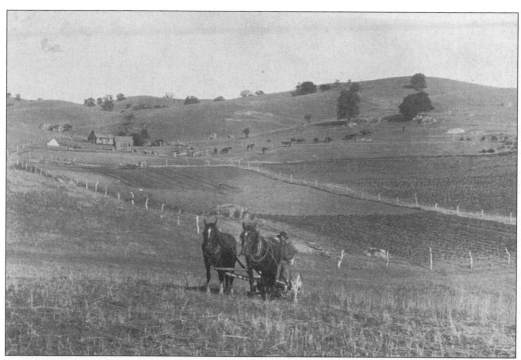

Farming developed in the fertile foothills east of Delano, and dry land farming became the norm due to the lack of an irrigation system. The annual rainfall was the catalyst for the success or failure of the crops. In this photo, Ben Launer plows the fields of his foothill ranch near Woody.

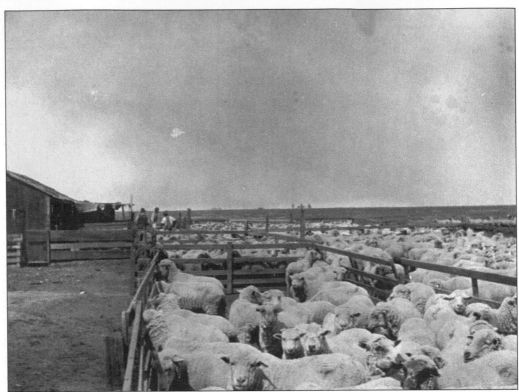

These sheep corrals were located northwest of Delano in 1912. The Zimmerman family herded their flocks of sheep into these pens for the season's shearing. Wool was the main source of income for many area ranchers.

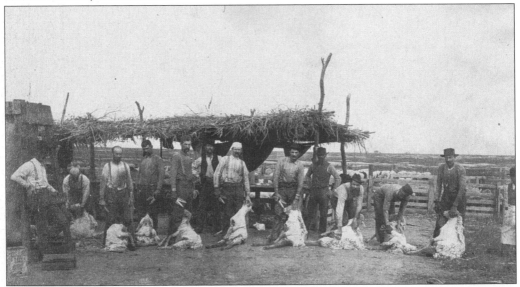

Before 1890, sheep herds were abundant in the area surrounding Delano, and many locals owned and operated sheep businesses. The Basque were readily involved in the shearing process and the raising of sheep. Each year sheep shearers would gather for the annual shearing of the sheep.

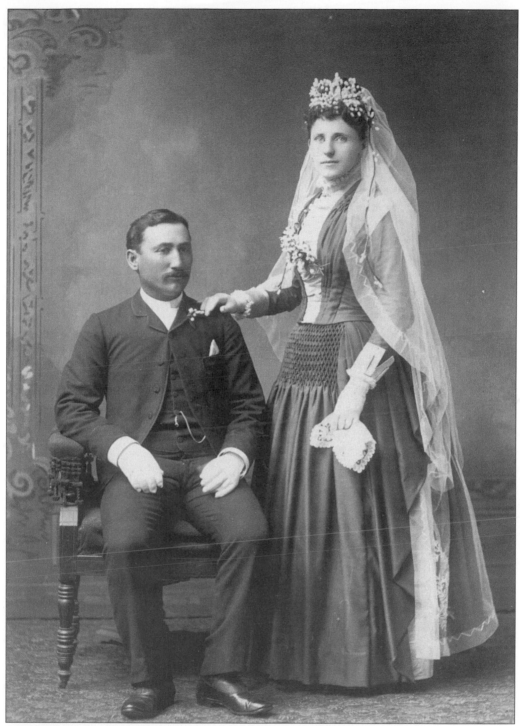

Alex and Bertha Zimmerman Kramer pose on their wedding day in 1889. The Kramer's homesteaded land located along White River four miles north of Delano in 1874. Alex Kramer owned flocks of sheep numbering in the thousands. The homestead, although smaller, is still in existence at the time of writing.

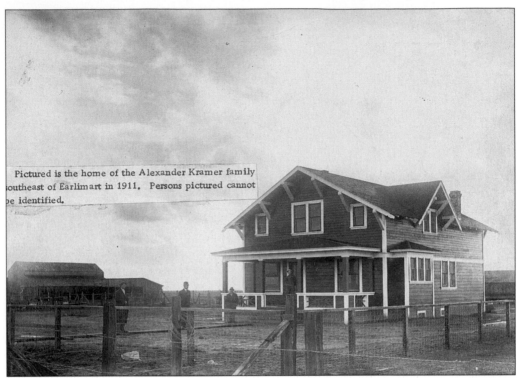

Pictured is the home of the Alexander Kramer family southeast of Earlimart in 1911. Persons pictured cannot be identified.

This is a 1911 photograph of the Alexander Kramer family home and ranch, located northeast of Delano on Road 144. Since White River ran through their property, the Kramers often faced the rolling floodwaters of White River when heavy rains caused the river to overflow its banks.

Water was and still is the number one commodity in the Delano area. Pictured here is Mr. Martin's Pumping Plant in 1905. Mr. Martin monitors the major influential faction of his ranching operation.

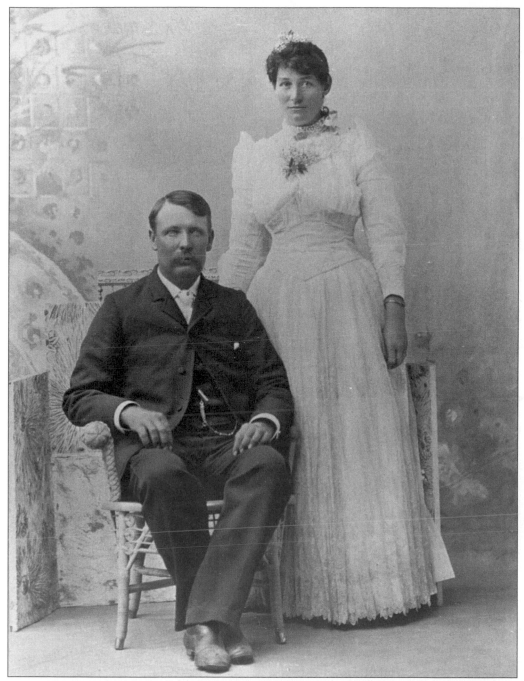

Alex Carver and Eugenia Woody Carver posed for this picture taken July 1895, two years after their wedding on January 5, 1893. The Carver family operated a flourishing cattle ranch in the foothills 16 miles east of Delano.

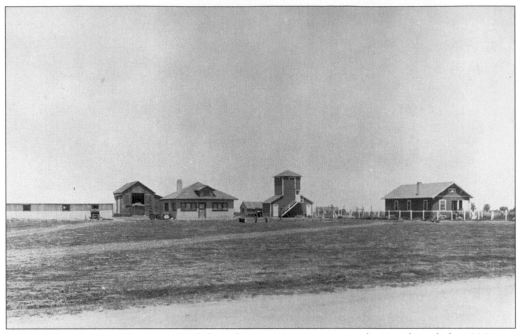

When Edward James Byrne retired from his engineering career, he purchased this 320-acre farm, located south of Delano on Highway 99 in 1909, which he worked until 1915. Mr. Byrne built a new home in Delano where he lived until his death.

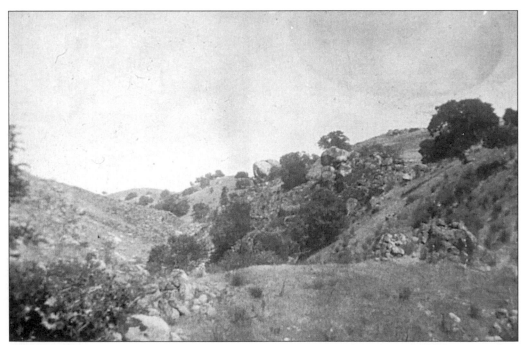

Rag Gulch was a source for water to irrigate crops in the eastern foothills, so a dam implemented by the Spangler brothers was constructed at the site. When gold was discovered in the area in 1853, miners migrated there using the water from the creek to pan their gold.

James Panero came to Delano with his family in 1883 and acquired a homestead. His sons, Joseph, James, Thomas, Daniel, and John (Frank, the youngest, was still in school), worked on their father's farm or hired out to neighbors.

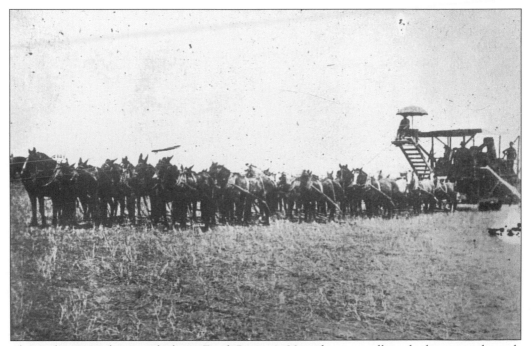

This early 1900s photograph shows Frank Panero's 20-mule team pulling the harvester through their wheat fields northeast of Delano. The men in the area took great pride in the horse teams and often wagered as to which team was the best.

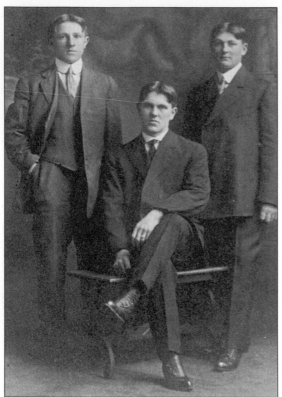

Bernhardt Michael Nielsen and his older brother James came from Denmark in 1908 and moved to Richgrove in 1911 to establish a ranch. This photograph of the three Nielsen brothers was taken in 1910.

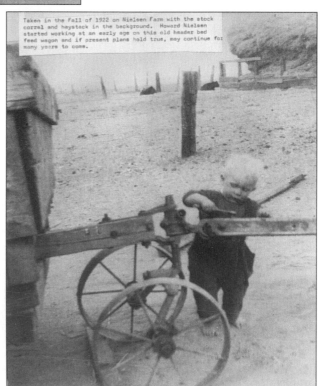

Taken in the Fall of 1922 on Nielsen Farm with the stock corral and haystack in the background. Howard Nielsen started working at an early age on this old header bed feed wagon and if present plans hold true, may continue for many years to come.

The Nielsen Farm appears here in the fall of 1922. At an early age, young Howard Nielsen started working on the 40-acre ranch, which was planted with its first wheat crop in 1912. For forty years, the Nielsen family farmed approximately three thousand acres of wheat every year.

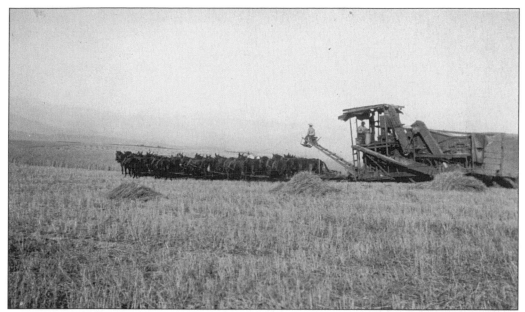

Horses and mules were used to power the huge grain combines and harvesters through the fields. Ranchers took great pride in their horses or mules, often bragging about the capabilities of their teams. (Photo courtesy B.M. Nielsen Ranch.)

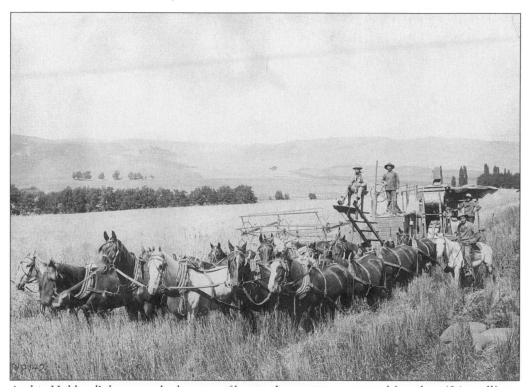

Archie Hubbard's harvester had a team of horses that was six across and four deep (24 in all). in This photograph, taken in 1890, shows the team pulling a large cumbersome machine through a field of dry land grain to harvest the year's crop.

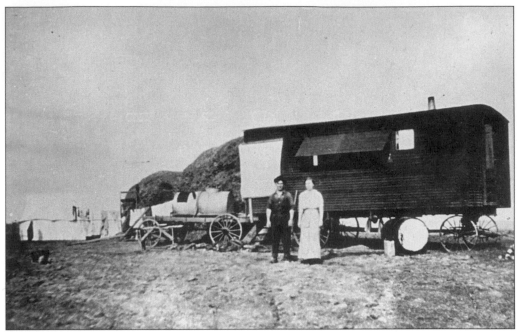

The original mobile home was photographed in 1914. The traveling cookhouse accompanied the harvesting crews into the fields offering a degree of comfort to the field workers. Often the ranch women managed the cookhouse, serving hot meals to the weary crews.

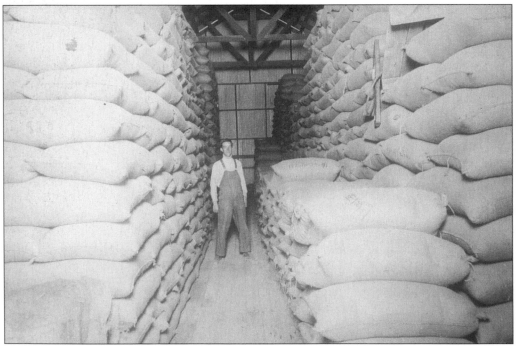

At the peak of the 1916 harvest season, stacks of grain were stored inside Tyler's Warehouse until they were shipped. The Tyler Warehouse, located next to the railroad, handled the majority of grain shipped from the Delano area fields.

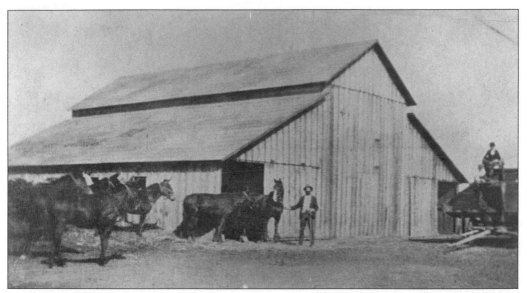

The Burum barn was home for the horses, mules, cows, and other animals on the farm. Several Burum family members, including Hugh Burum and William Burum at age ten, pose for the camera in 1922. The barn was the hub of most farms and ranches giving shelter to the animals and feed grains.

George L. Robertson relaxes on the porch of the Levi Thorner home north of Delano. Mr. Robertson bought the farm in 1906 and later sold it to newcomers. He was a successful pioneer rancher and real estate broker throughout the Delano area.

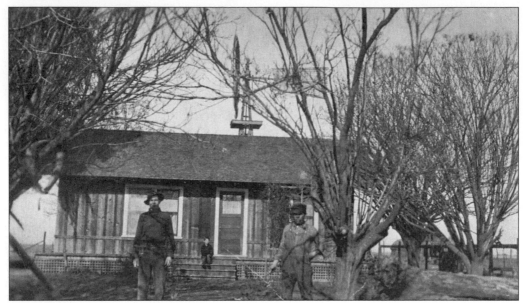

Originally owned by Charles Jackson, the Escalle property was purchased by Frank M. Kee in 1909, then sold to Escalle in 1914. Marvin Porter, Lucien Escalle (eight years old, seated on the porch steps), and Allie Escalle are pictured in front of the house. This photo was taken in 1915.

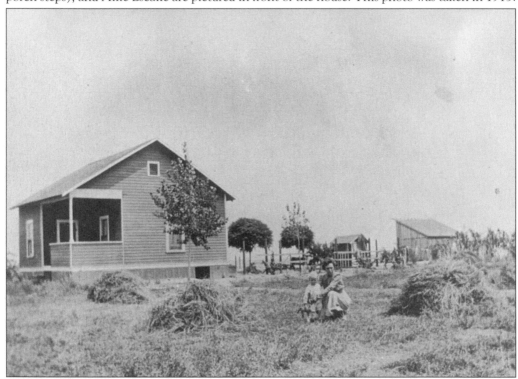

In this 1913 picture of the Charles Bassett Ranch, Kathryn Bassett, age two, and Ethel Bassett appear in the yard. Charles Bassett married Ethel in 1910, and they came to the Delano area to ranch and establish a home. Charles Bassett's farming practices were diverse; he raised grapes, olives, wheat, fruits, and vegetables.

Built in 1912, this house was located on 320 acres at the corner of Cecil Avenue and Stradley Street. The property was owned by McBride-Harville. The 1914–1915 Model Studebaker was owned by Minor Felver in 1918. Minor Felver and Fred Fairservice purchased this property in 1920.

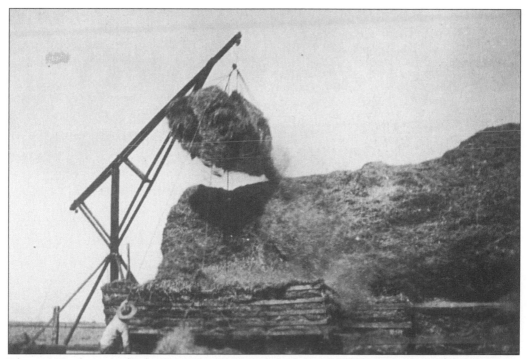

This 1925 photograph shows a typical hay derrick used for stacking loose hay or straw. The horse pulled the load swinging it over the stack. Hay was one major source of animal feed and was stored to feed the livestock during the off-season. (Courtesy B.M. Nielsen Ranch.)

The Headrick Homestead appears here in 1912. The house was built around 1885. Note the windmill behind the trees. Nearly every home or farm obtained water by way of windmill power into the early 1900s. In the foothills, one can find windmills still pumping water for livestock ponds.

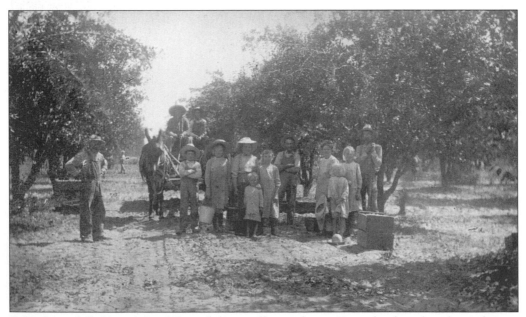

D.B. Conrad (left) and Cecil Dyar (bib overalls standing next to the driver) pick peaches on the Conrad Ranch, located west of Richgrove, in 1925. The others pictured are unidentified. The ranch was a mile north of County Line Road and Road 184 (east of Delano).

Four

PIONEERING FAMILIES

The Bertrand family is pictured as follows: Anias Aubin Bertrand, Joseph Bertrand, Mary DeVoto (holding Elise DeVoto), Henry DeVoto, Elise Bertrand Jones, Pete Aubin, and Mary Aubin (holding Albert). When Joseph Bertrand arrived in Delano in 1908, he established a shoe repair shop and operated it for 39 years.

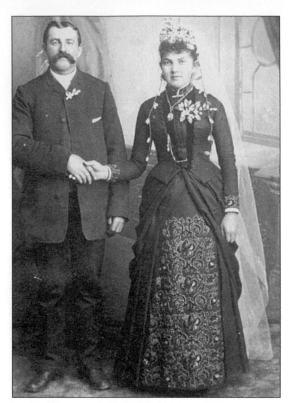

Celestin Rostain and Annis Villard pose for their wedding photo in 1866. They arrived in the Delano area the same year, purchasing land with Ambroise Villard and going into the sheep business. The couple raised six children.

Mr. and Mrs. W.B. Timmons and family arrived in Delano on September 9, 1887, and homesteaded a parcel of land for raising cattle and farming. President Harrison appointed Mr. Timmons as postmaster of Delano in 1889.

Julius Bailey, born in 1850, brought his wife and two children from Minnesota to Delano in 1875. His youngest child, Flossie, was born in Delano in 1890. Julius was killed in an accident in 1902.

Minnie Bailey, born in 1860, arrived with her husband Julius and two children in 1875. Widowed in 1902, she supported herself and daughter by working as a practical nurse. Later she married John Smith. Her youngest daughter Flossie owned and operated the "Bon Bon Shop" in Delano until it was destroyed by fire in 1915.

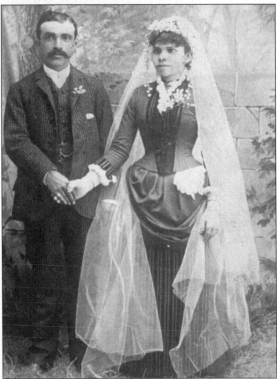

The Cecil family is pictured here in 1904. Daniel Leander Cecil came to Delano in 1874 as Station Agent for the Southern Pacific Railroad and purchased land north of town. The family donated a parcel of land for a park, and Cecil Avenue Park was established at the corner of Norwalk and Cecil Avenue.

Frank and Maria Roderick Claudio pose on their wedding day in 1888. Frank filed on 160 acres of land east of Delano prior to 1889. Later he added another 160 acres and expanded his dry land farming practices.

The H.L. Taylor family is pictured in 1891 as follows: Henry Taylor, Cecil, Mrs. Taylor, Walter, Lloyd, and Maude. They arrived in Delano on May 14, 1891, purchasing a homestead three miles south of Hunt Station (McFarland) and farmed dry land grains.

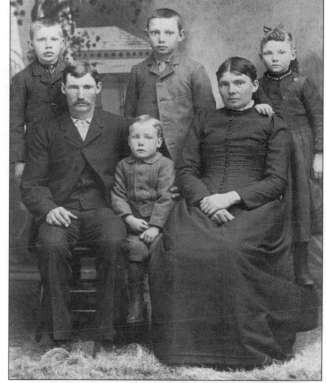

Addue Slocum, Tom Slocum and Vashti Timmons appear here in this 1900 photograph. Edward Timmons, son of Vashti Timmons, arrived in Delano on September 9, 1887. They farmed the area around Delano from about 1902 until they moved to Bakersfield in 1921.

The G.S. Scott family appears here in 1917. George Scott first saw the Delano area in 1876 while moving cattle to the Mojave Desert. They moved to Delano in November 1906, leasing a part of the Quinn property for dry land farming. Mr. Scott purchased and leased land to the extent of five thousand acres for raising grain. He owned one of the first gasoline tractors in this area.

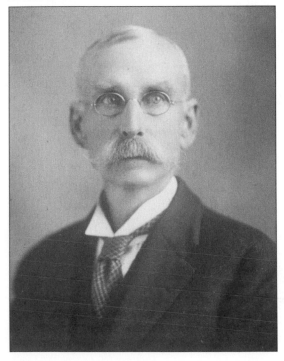

Edward J. Byrne came to Delano after retiring from engineering in 1907, and purchased land in the Delano-McFarland area east of Delano. At his home located 320 acres south of Delano, he ran a farming operation until retiring in 1915.

Mr. and Mrs. R.H. Hiett Sr. brought their six children to Delano in 1909. In 1916, they started a dairy and milk delivery service in Delano, which they named Crystal Dairy. The undertaking proved to be a family operation. This photo was taken in 1924.

Minnie and Roswell Wilbur stand in front of their home at 1008 Eleventh Avenue on October 17, 1909. Roswell served as postmaster in Delano during the 1920s.

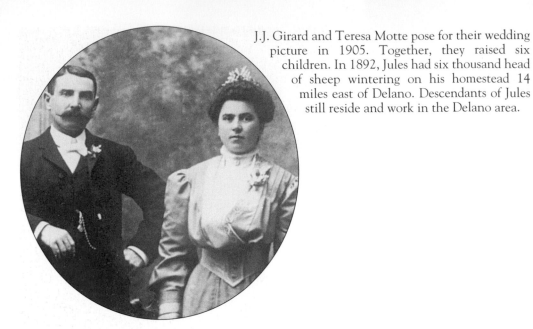

J.J. Girard and Teresa Motte pose for their wedding picture in 1905. Together, they raised six children. In 1892, Jules had six thousand head of sheep wintering on his homestead 14 miles east of Delano. Descendants of Jules still reside and work in the Delano area.

Alcario Martinez and Teresa Cecilia Nunez are pictured here in 1913. Alcario sheared sheep in the foothills of Delano for Miller & Lux, and worked as a cowboy for Harry Quinn. He worked as a truck driver for Roy Woollomes, Kern County's first district supervisor, until he retired.

Delbert and Maude Cook married in 1914, the year this photograph was taken, and then moved to Delano. He graduated Veterinary College with the highest honors ever achieved and started a practice in McHarvey's Livery Stable, which he later purchased. He was Delano's first city clerk when the town was incorporated in 1915.

The Charles Dawson family in 1924 is pictured, from left to right, as follows: Charlie and Opal Dawson, baby Kenneth Dawson, Wayne and Charles Dawson Jr., Mrs. John Fulwiler, Claribe Fulwiler, Willie Marie Fulwiler (Harcourt), and Fern and John Fulwiler. They resided on 40 acres near Earlimart until moving to Delano.

Marie, Grey, and Cora Woosley pose outside their family residence in about 1921 or 1922. Little is recorded of the Woosley family, but their presence was visible throughout the history of Delano.

The W.H. Cole family poses on Easter Sunday in 1930. Arriving in 1912, the Coles ran a dairy and raised beef until 1924. Henry Cole was the great-grandson of Hannah Cole, the first white woman to cross the Missouri River. Members of the Cole family have been major players in Delano's growth and development.

Five

AGRICULTURE

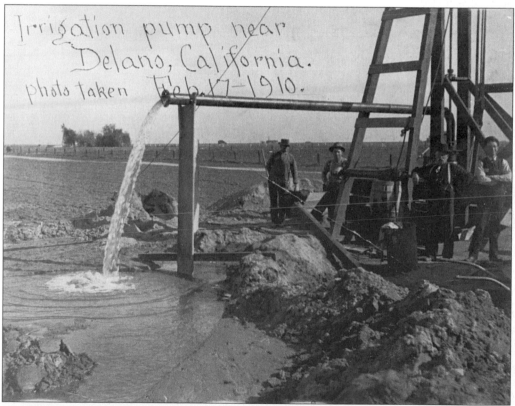

Irrigation pump near Delano, California. photo taken Feb. 17-1910.

The lifeblood of agriculture is the availability of water. This photograph taken February 17, 1910, represents the first irrigation wells drilled near Delano at the corner of Stradley Road and Cecil Avenue. Pictured second from right is Frank Harville, father of Maud Fairservice, who lived on the property.

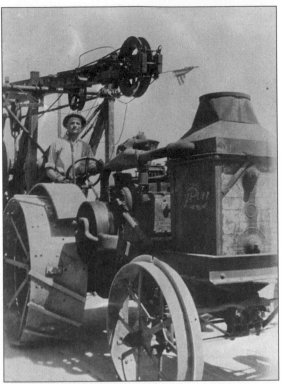

Gene Whitten sits in the driver's seat of the tractor pulling Frank Schlitz's cable-bit drilling rig. The rig was used extensively throughout the Delano area to drill for water needed to irrigate crops This photo was taken in 1920.

A photo of the Hedrick Homestead with its large brick water tank and small brick horse trough looks east. The children pictured are Merle Scott (one-time chief of police in Delano) and Norval Dyar.

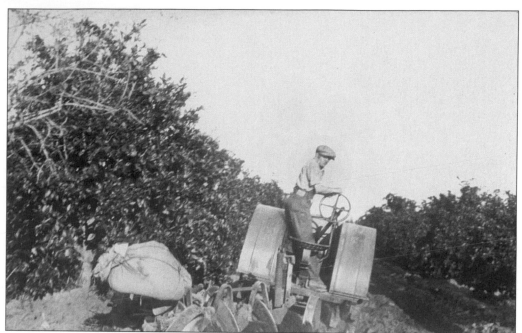

In the spring of 1926, one might have found local farmer Harry Goodell disc plowing a young orange grove. Goodell's family developed an orange grove in 1916, seven miles east of Delano in the Jasmine area.

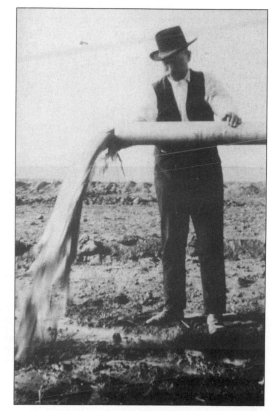

Local rancher Bill Browning checked his precious water system regularly in the 1920s. The farmers had to maintain their individual irrigation systems. Browning's water supply determined the quality of his crops and the amount of water available for his family's daily use.

In 1928, Sierra Vista Ranch was a major farming, ranching, and packing organization east of Delano and north of County Line Road. This is a view of one of the styles of trellises used by grape growers in the area.

In the spring grapes must be prepared for the growing season. A local field worker in this 1927 photograph is operating one of the first brush shredders to enter California. He clears the rows of weeds and brush to ensure healthy growth of the vines.

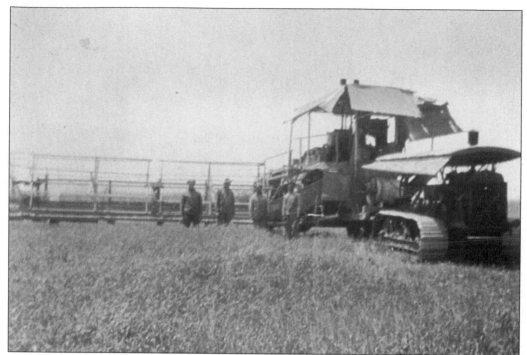

With the advent of mechanization, farmers and ranchers were able to increase their farming operations. In 1917, George Scott used this thresher to cut his dry land wheat, cutting his field time in half.

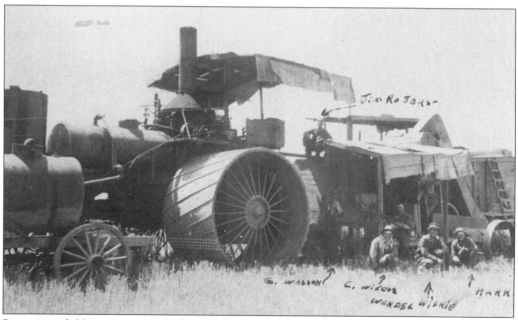

Pierson and Vieux are pictured with their crew in 1906. This steam combine harvester manufactured by Holt Manufacturing Company made it possible for his crew to cut about six thousand acres per season for local ranchers.

Charles Bassett had one of the first wells and irrigation systems in the area. With an abundant water supply, Mr. Bassett's wheat fields, which were located east of Delano and north of Cecil Avenue and Driver Road, would give him a bumper crop.

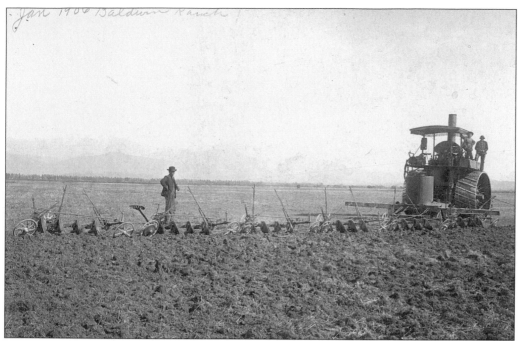

Pictured on the Baldwin Ranch in January 1906 are Albert Clark, G. Miller, and Elmer Bohanan. The steam-powered tractor and its long line of disc blades were used to till the soil. With tractor power, farmers were capable of tilling additional land, doubling or tripling production.

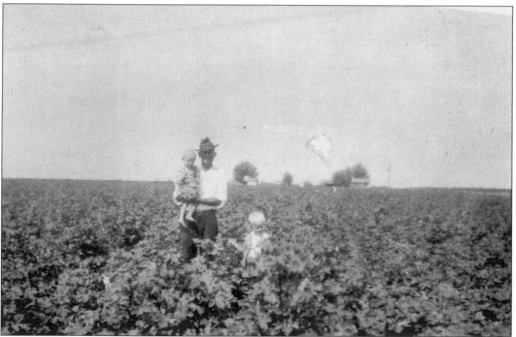

In July 1925, Albert Swanson with his sons Jack (in his arms) and Al Jr. survey this season's cotton crop just as it begins to take on blooms and form the green cotton bolls. Cotton was becoming the major money crop in the Southern San Joaquin Valley.

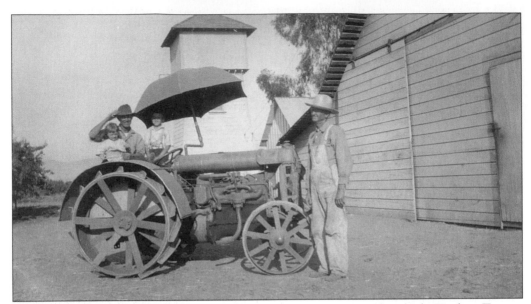

The Clark family, including Anita, Alfred, and Derrell pose in 1920 beside the Fordson Tractor that supplied the additional horsepower needed in their growing farming operation. With the availability of tractor power, many backbreaking tasks were eliminated.

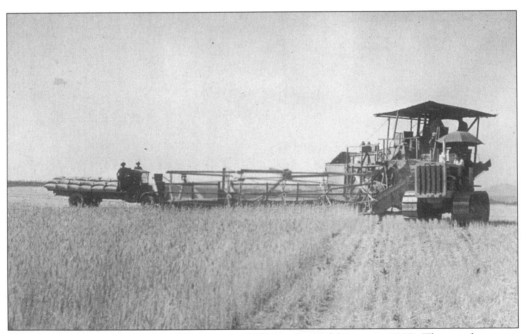

The development of the Holt Washington Hillside Special began in 1929. The machine was field tested in 1930 and used by the B.M. Nielson ranch to harvest their grain, which covered several thousand acres.

Sierra Vista Ranch, a major player in farming operations east of Delano, was a diversified farm, growing grapes, almonds, fruits, and other produce. Superintendent Norman Schults surveys an orchard near Wallace Road as one of his many duties for the company.

In the spring of 1914, the view on Garces Avenue was quite beautiful as the blooms from the rows of almond trees forming the orchards brightened the landscape. E. Curtis Clark owned the orchards.

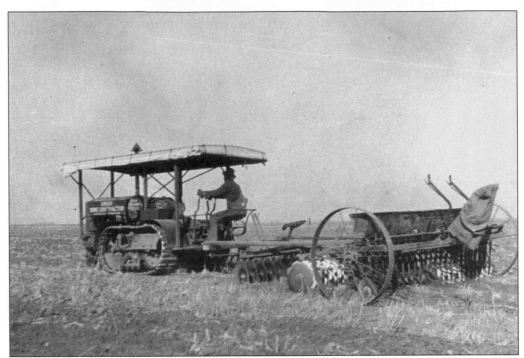

With the approach of the fall season in 1924, local farmer John Cramer pulls his grain planter, seeding his fields for the next year's crop of wheat. Foremost on his mind was the prospect of rain needed to germinate his seed and foster the growth of his dry land crop.

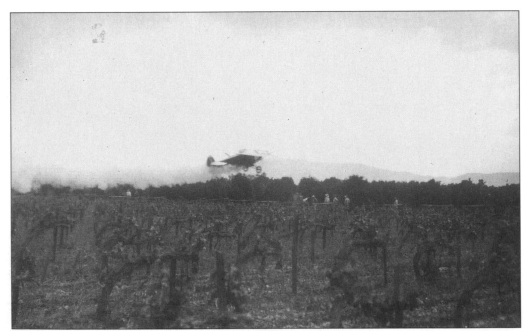

A plane flying over a local vineyard sprays (crop dusts) the sprouting vines. As the variety of crops increased throughout the farming community, the impart due to improved water supplies brought insects, disease, and moll-damaging crops.

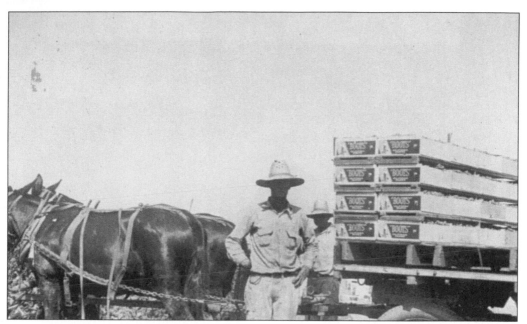

This wagon sits piled with boxes of field-packed grapes. In 1928–29, the mules and wagons brought the grapes to the end of the fields where they were transferred to trucks or taken directly to nearby cold storage to be held or shipped to market.

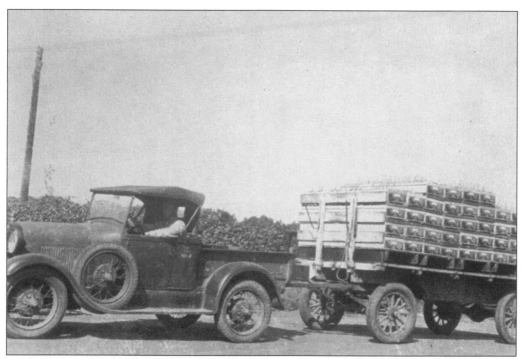

A Model A Ford pulls a wagon of field-packed grapes from the fields in 1928 or 29. Grapes were a major crop for local farmers who grew them for the table and local wineries.

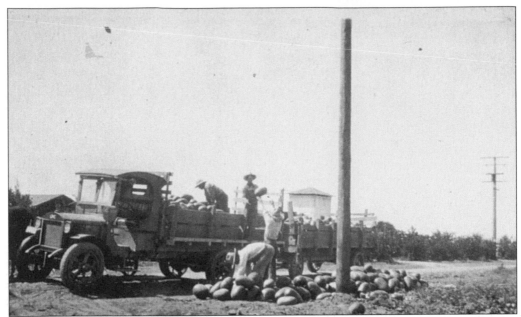

In this photo from 1927, field workers carry watermelons from the Bassett's fields and load them onto trucks headed to the rail siding in Delano. From there, they were loaded onto a train headed east.

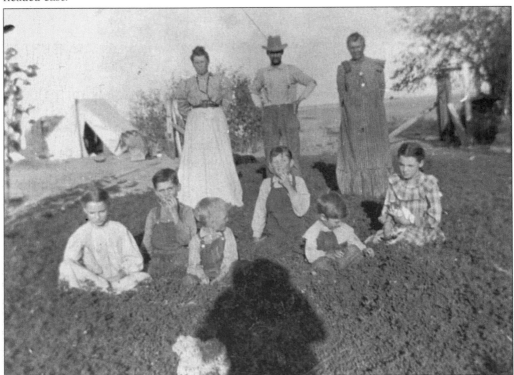

A 1904 photograph of the Whitten family shows: Lilly Dolly, Ernie Whitten, Ed Whitten, Joshua Whitten, Gene Whitten, Blanche Dolly, Mary Ellen Whitten, and Jim and Agnes Taylor. Note the tent in the background.

This photograph of the Sierra Vista Ranch Packing House, located just east of Delano 1/2 mile north of County Line Road, was taken during 1927. The field grapes were taken in gondolas (wagons) to the packing house, where they were graded and packed to be shipped to the eastern markets.

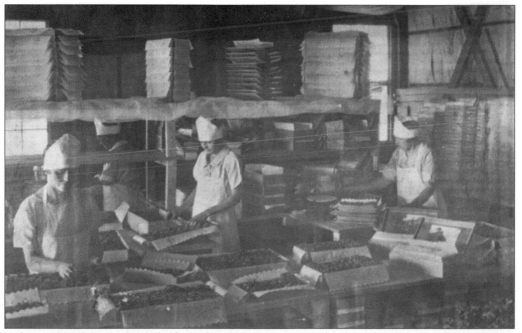

Delano's first fruit packing shed was located at Garces Highway and Driver Road. Mrs. Moss, pictured second from the left, and Mrs. Cate (right) packed dried fruit on the Cate's Ranch. Orchards of peaches, apples, oranges, and grapes grew in nearby fields. This photograph is from 1925.

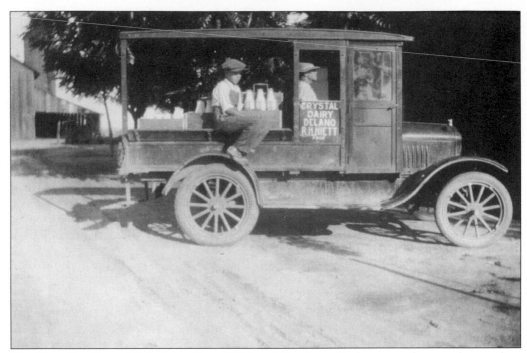

The Hiett Family established the Crystal Dairy, delivering milk, butter, and cream door to door in the Delano area. This photograph of the delivery truck was taken in 1916 and shows R.H. Hiett and Albert Hiett doing the daily deliveries.

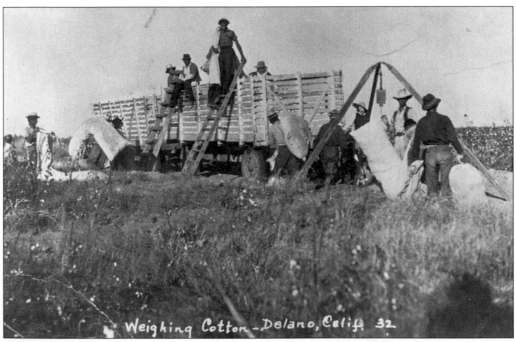

During the early 1920s and 30s, cotton was picked by hand. The procedure involved picking the cotton and placing it in long sacks dragged behind the picker. The sacks were weighed, the picker was paid in cash, and then the sack was dumped into the cotton trailers.

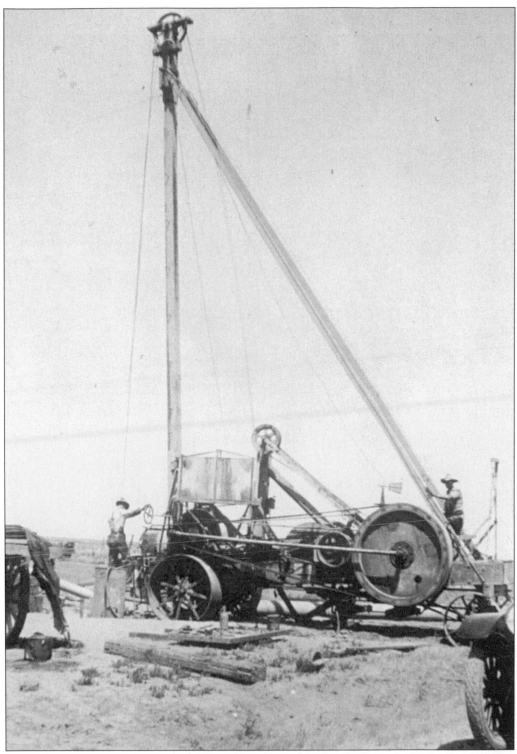

This drilling rig owned by Frank Schlitz was used in 1921. Jot Whitten and Billy Grey operate the rig as they drill for much-needed water on a nearby ranch.

Located on the corner of Fourteenth Avenue and Lexington Street was the Southern California Edison Company, formerly Mt. Whitney P & E Company. Posing for the camera are (left to right) Bill Martin, unidentified, Clarence Kramer, Fred Edwards, unidentified, unidentified, Angel Borel, unidentified, Rodney Bacon, and two unidentified.

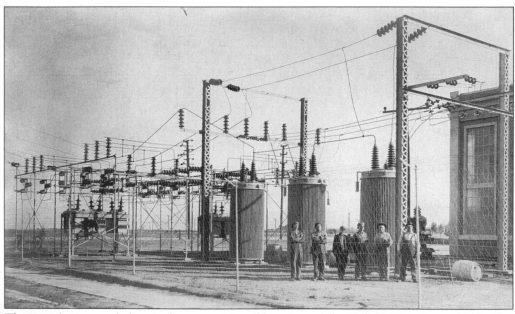

The transformers and electrical system pictured here served the Delano area during 1919. This was an extension of the Southern California Edison Company, located at Fourteenth Avenue and Lexington Street. The photo was taken in 1920.

Six

BUILDING A
COMMUNITY

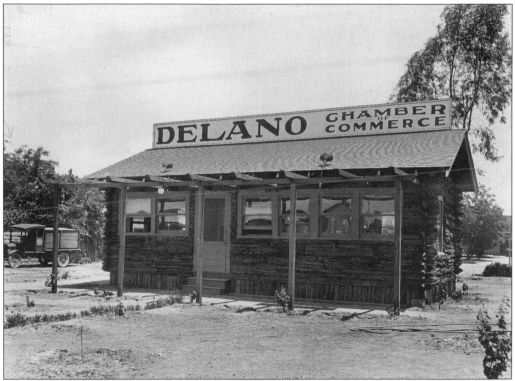

The Delano District Chamber of Commerce building was located south of Eleventh Avenue on High Street, facing the Southern Pacific railroad tracks in 1920. The Chamber of Commerce was organized and reorganized at various times in the early years. Record keeping began in 1924 with J. Seekler as president.

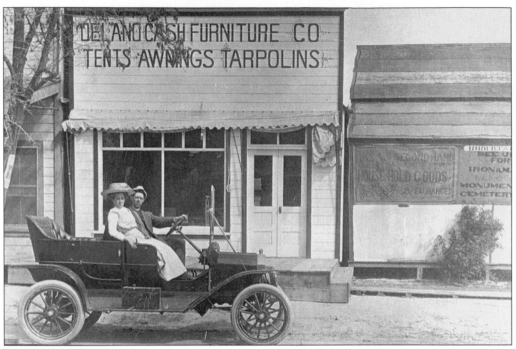

Delano Cash Furniture Company, operated by manager L.C. Sharp, offered local residents their choice of furniture, carpets, linoleum, oilcloth, wallpaper, and the latest designs for the spring of 1909.

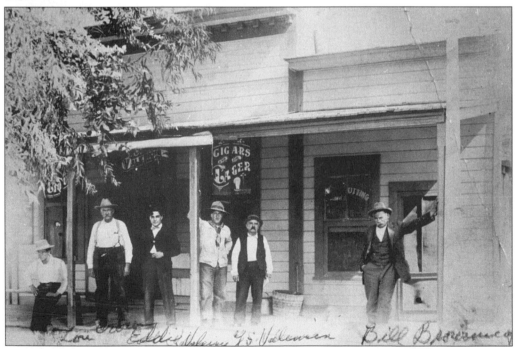

A barbershop and bar in the 1000 block on High Street was owned and operated by Y.S. Valencia after 1890. Mr. Valencia and his son Eddie (center) are pictured here. In 1874, Ygnacio opened his businesses next door to Chauvin's store.

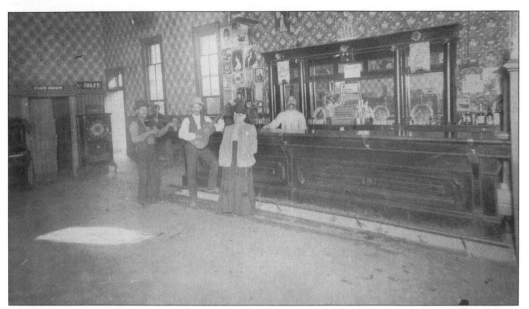

Ygnacio Valencia, a prominent businessman in Delano's earliest beginnings, owned this saloon in 1890. Mr. Valencia had diverse business interests in the city and his was one of the first Hispanic families to come to the area. Many of his offspring are still residing here.

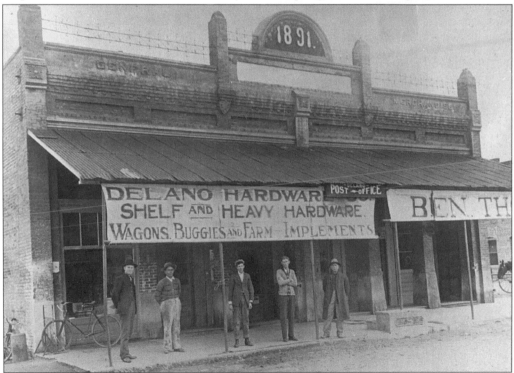

In 1887, Charles Weaver established the Delano Hardware Store on Main Street. Over the years, the store continued through several owners supplying the citizens with items from heavy hardware to stoves and ranges. In this photograph taken in 1907 are, from left to right, Otto Classen, Ward Robertson, Guy Turner, and John Headrick.

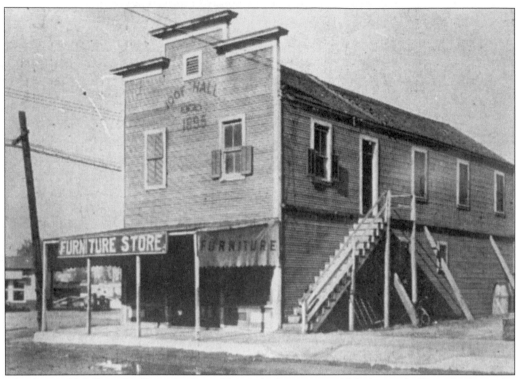

The first Odd Fellows Hall was built on Eleventh Avenue in 1895. A new hall was built on the same site in 1925. The first floor housed a furniture store, while the second floor served as a meeting place.

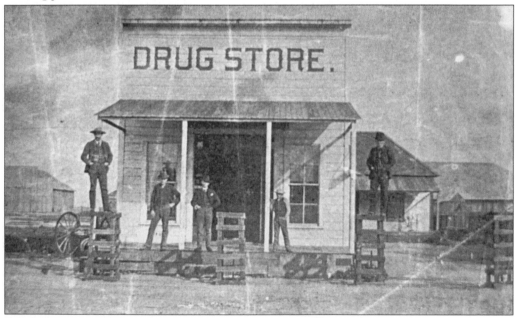

E.H. Ramsey started the first drug store in 1887. The Pioneer Drug Store, located in 1100 Block of High Street, was destroyed in the fire of 1892. Mr. Ramsey rebuilt the Ramsey Drug Store, which burned in the fire of 1915. Following that fire, he bounced back with another building.

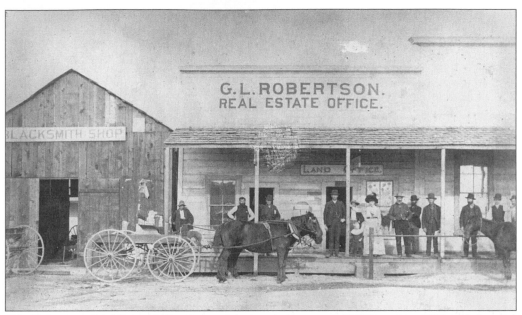

G.L. Robertson Real Estate Office burned during the summer of 1890, and in 1892, another fire destroyed the entire corner, known as Davis Corner. Pictured here in 1888 are as follows: Dave Abbott, Hanson (the shoemaker), T. Hamlin, George Lee Robertson, Anna Bell Robertson, Mrs. Mollie Robertson, Tom Clark, (Old Man) Dyer, John Tyler, O.R. Pouncelet, unidentified hotel clerk, and F.E. Davis.

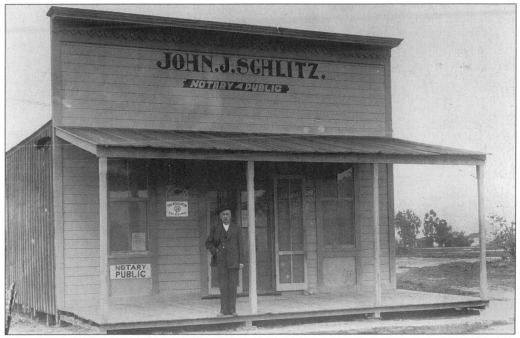

John J. Schlitz stands in front of his office, located between Main Street and Jefferson on Eleventh Avenue (south side), in about 1920. One cold winter night in 1917, the office was destroyed by fire. Mr. Schlitz handled rental property, collecting and looking after the interest of non-resident landholders, while making conveyances and legal documents as a notary public.

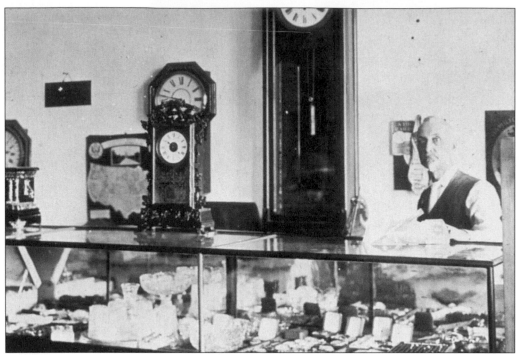

Pictured here in 1909 is Wilbur's Jewelry Store, located in Ramsey Drug Store. R.M. Wilbur supplied the community with clocks, jewelry, and his good taste in luxury items.

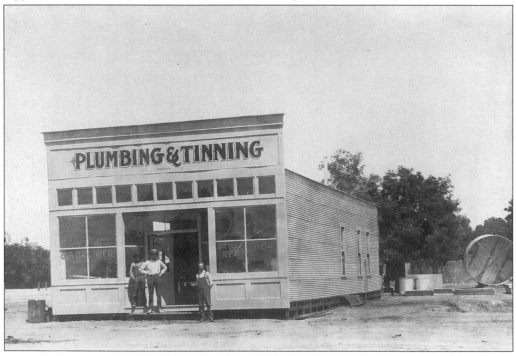

In 1909, G.A. Brunner Plumbing offered the skills for sheet metal work plus the knowledge of pumps, pipe fittings, brass goods, and tanks of all sizes for the flourishing area surrounding Delano.

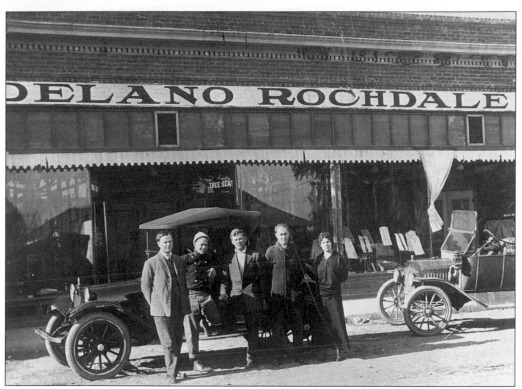

P. Hammer, Lawrence Hileman, Walker Thomas, and Mary Borel stand in front of Delano's Rochdale Store in 1915. Located on the west side of the 1100 block of Main Street, this was a general merchandise establishment offering items from underwear to silverware.

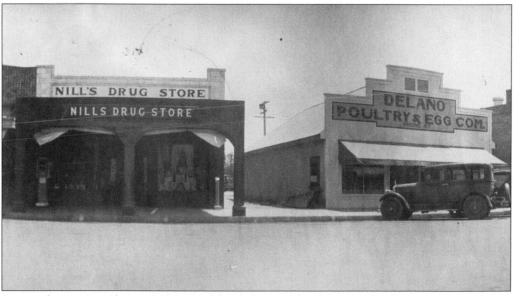

During the 1920s and '30s, Steven Douglas Nills owned and operated Nill's Drug Store at 1016 Main Street. The Delano Poultry and Egg Company, run by Dave Shifflet, was located next door. Baseball fans might remember the 1921 World Series being relayed to Shifflet's in half-hour bulletins over his crystal set.

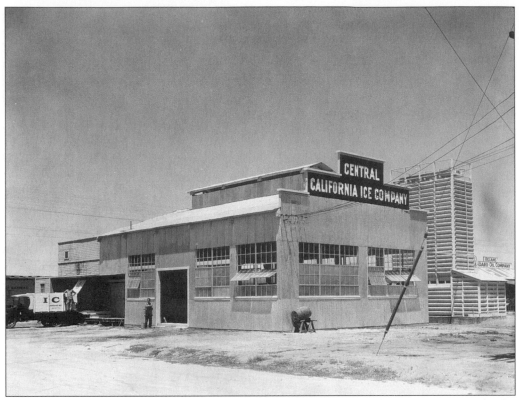

This photograph of the Central California Ice Company was taken in 1920. With the development of the ice companies, fresh produce could be shipped from the local farms to market in the east, or the fresh products stored until it was convenient to ship.

Standard Oil Company, located between the railroad tracks and High Street (Front Street), appears here in 1921. In the foreground (center), note the hay loft in the building where the fuel wagon horses were stabled.

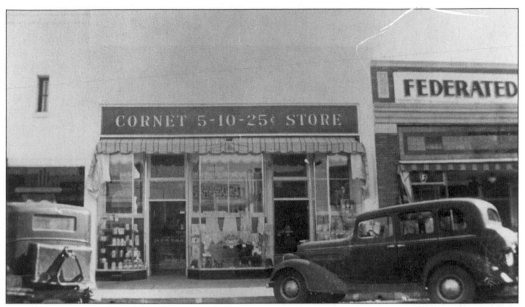

In 1930, Cornet's Five and Dime served the community from the 1100 block (east side) of Main Street. It was a general merchandising outlet, which later expanded into the Cornet Mall. Cornet left Delano in 1996.

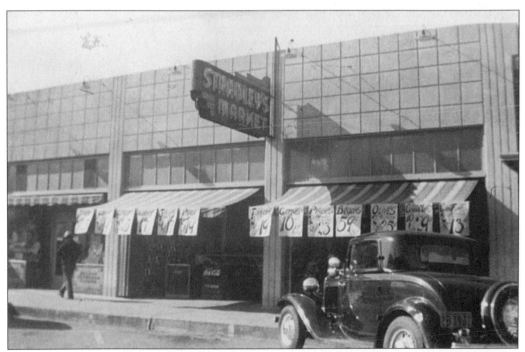

In business since 1919, Stradley's Market became a fixture for downtown Delano. This last family-owned grocery store on Main Street was located on the west side in the 1000 block.

Mr. Tefft poses here in his automobile in front of the house at Eleventh Avenue and Lexington Street. Mr. Tefft was related to the Ramsey family, whose house appears on the left. Mr. Ramsey owned the drug store in Delano.

The home of Sterling Lincoln Cole was built before 1900 at the corner of Twelfth Avenue and Madison. It was destroyed by fire in 1960. Mr. Cole engaged in the cattle business and the farming of alfalfa and cotton in the surrounding area.

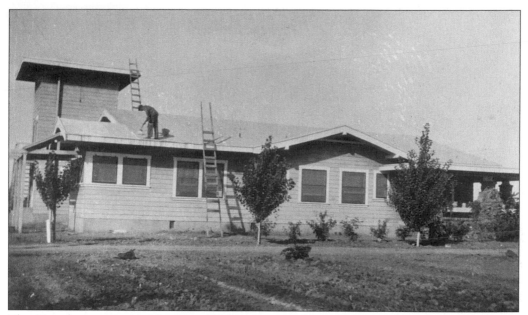

The Dyar home, pictured here in 1923, was situated on 80 acres of farmland eight miles northeast of Delano. The Scott-Dyar families came to the area in 1906. The Dyars farmed grapes and dry land wheat.

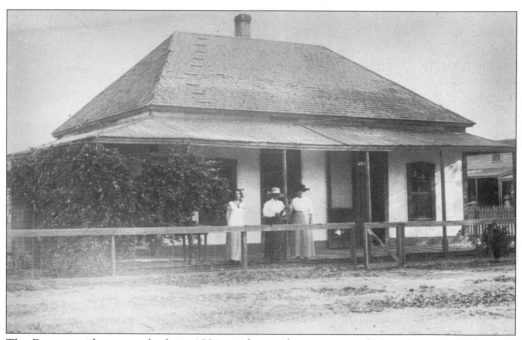

The Boone residence was built in 1884 on the southeast corner of Main Street and Eleventh Avenue. This photograph of the adobe building with wood construction was taken in 1908. The ladies standing in the yard are unidentified.

This photograph gives a glimpse of the house built by A. Sheppard in 1840. Located at 1031 Lexington Street, it has since been torn down and replaced with a parking lot.

John Hedrich, an early pioneer of the area, resided in this home at Eleventh Avenue and Lexington Street in 1910.

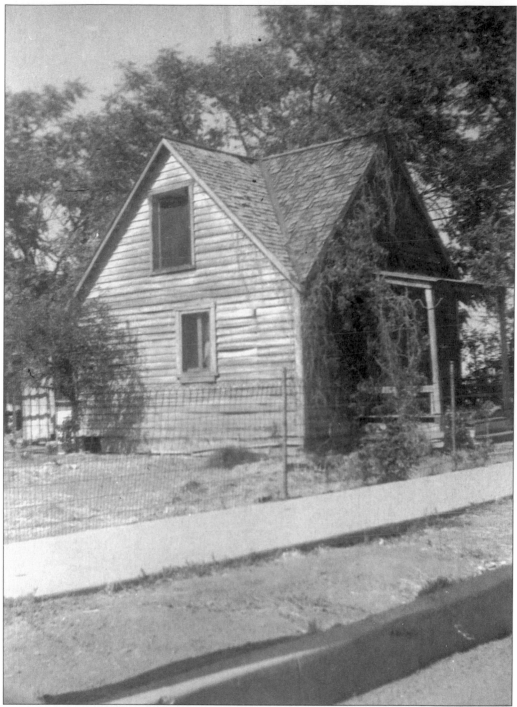

Heritage House was built in 1890 on Glenwood Street and served as both home and office for Jules Daval, who came from France to establish a horse breeding business. Mr. Stien moved the house to the Belle Mitchell property on Eleventh Avenue in 1915. The house became part of the Wong Estate in 1927. Emma Wong deeded the house to the Delano Historical Society in 1961.

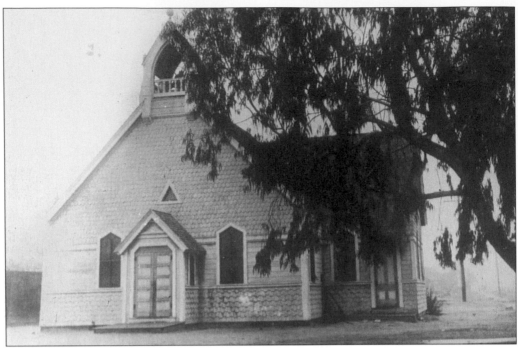

The First Methodist Church was constructed at Thirteenth Avenue and Main Street in 1888. In 1925, the building was made into apartments and a new church was built.

This photograph of the First Methodist Church at the corner of Eleventh Avenue and Jefferson Street was taken on April 8, 1928. The parsonage is located east of the church, on the corner of Eleventh Avenue and Kensington Street.

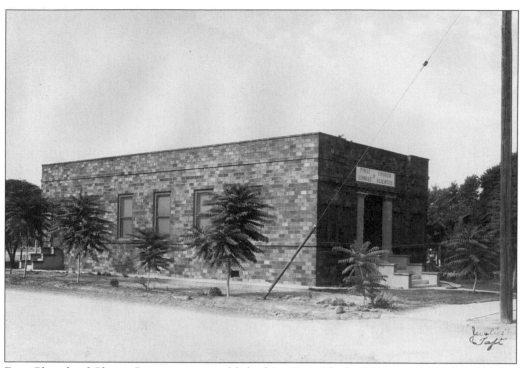

First Church of Christ, Scientist was established in 1910. The building was erected in 1924 at the northeast corner of Eleventh Avenue and Kensington Street.

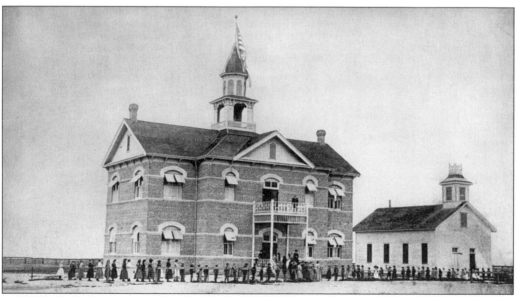

In 1884, a brand-new one-room school was built to educate Delano's children. The small white building (on the right) served the area until 1888, at which time a new two-story school was constructed (on the left) to accommodate the increasing population. The construction of the Fremont School in 1915 used the bricks from the two-story building.

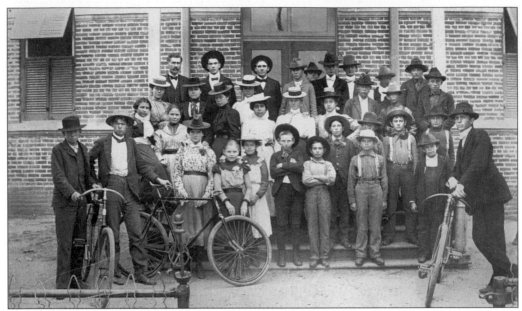

Professor John Mercer's class of 1897 is pictured, from left to right, as follows: (front row) Charlie Dorsey, George Weaver, Belle Cuevas, Ethel Crans, Margie Quinnk, Trina Latimer, Edith Weaver, John R. Quinn, Eddie Valencia, Amos Weaver, Willie Silber, unidentified, Forrest Cassidy, C. Valencia, Frank Cassidy, and Don Turner; (second row) Maude Kefer, Zorada Timmons, Ethel Weaver, Victoria Cuevas, Trina Valencia, Anna Belle Robertson, Rachie Hobart, Clay Thomas, unidentified, Harry Crans, and Martin Wasson; (top row) John Mercer, Walter McDonald, Everett Timmons, Bert Lockridge, Willie Norton, Buy Turner, and Orie Robertson.

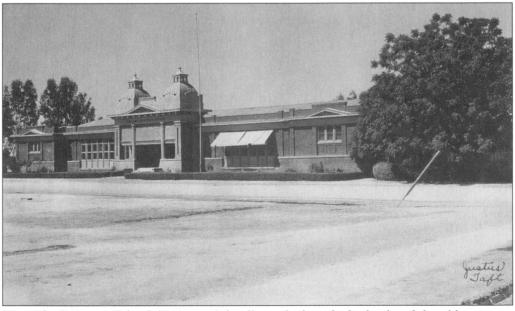

Westside Grammar School (Fremont School) was built with the bricks of the old two-story school in 1915. The building eventually fell prey to the 1952 earthquake and the new freeway that cuts through Delano west of the Southern Pacific Railroad.

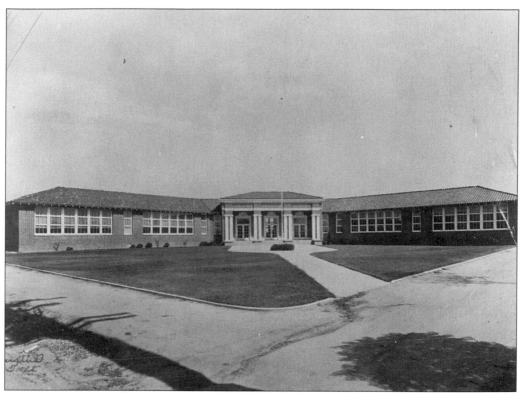

Cecil Avenue School was built on the corner of Cecil Avenue and Norwalk in 1923. The original structure consisted of four classrooms, an auditorium, and an office. All evidence of the original building was lost with its expansion and remodeling in the mid 1960s.

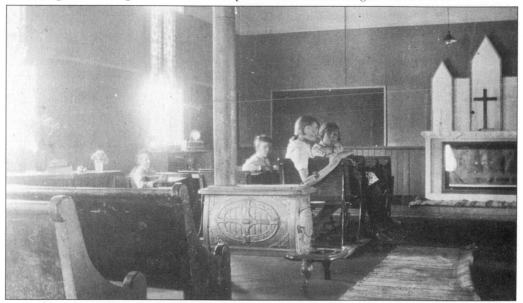

In 1925, Lutheran Parochial School was located at Thirteenth Avenue and Fremont Streets. Gaylord Monsees, Marvin Monsees, Fanchon (Klassen) Blank, Ruth (Blank) Rinckhoff, Edward Kraft, and Viola Kraft appear in the classroom.

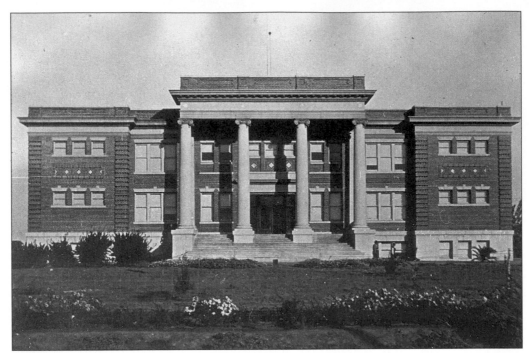

The Delano High School was constructed in 1912 in the middle of a wheat field. Students struggled through the sagebrush, sand, and puncture vines to reach the isolated structure, which stood as a majestic symbol to higher education. Following the earthquake of 1952, the weakened structure had to be torn down and replaced by the current high school.

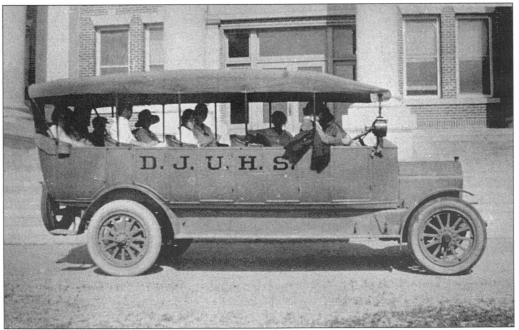

Pictured here in 1918 on the Delano Joint Union High School bus are Elsie Gange, Beryl Kee, Mary King, Ruth Higley, Lila Moore, Chester Miller, and Iva Reed. Many students from outlying areas rode the bus to and from school each day.

Seven

FIRES AND FLOODS

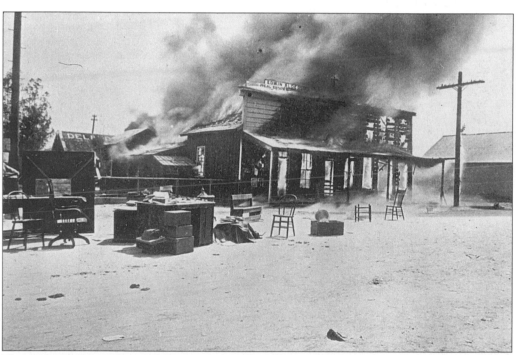

The fires of 1887, 1890, 1915, and 1917 would go down in living memory as the most terrifying fires in Delano's history. Once a fire started it usually meant total destruction of the town's wood structures. Then, the struggle to rebuild the town began. This photograph of the 1915 fire was taken as it raged through Edwin Alderson's Real Estate building and garage facing east on Main Street.

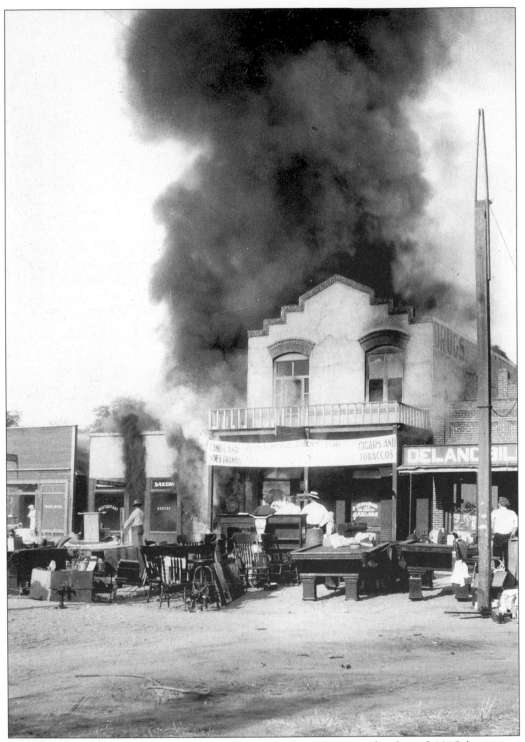

Smoke escaped through the windows of Ramsey Drug Store as the fire of 1915 begins its rampage consuming Main Street. Neighbors entered the threatened buildings dragging precious belongings into the center of the street as they waited for the fire to run its course.

94

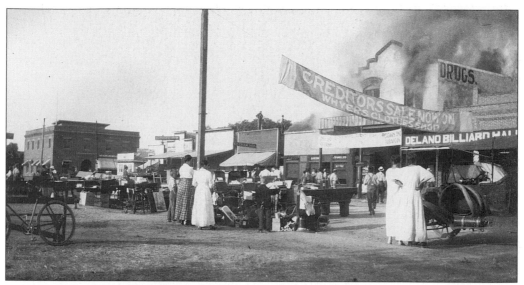

Delano citizens stand behind the furnishings piled into Main Street and watch the drug store, billiard hall, and neighboring businesses burn, knowing that the fire will move down Main Street and eat away at the wooden structures.

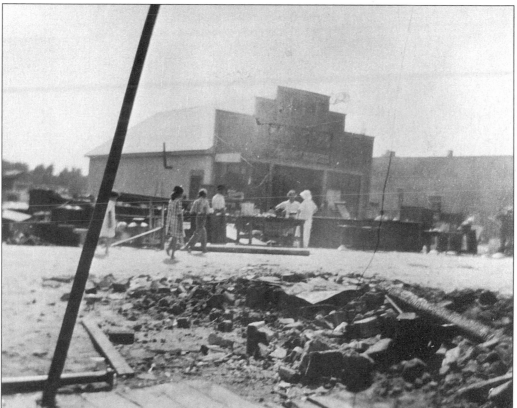

The fire of 1915 destroyed Flossie Bailey's Ice Cream Parlor as it roared down Main Street. The aftermath of the fire is shown here. The ice cream parlor was never rebuilt after the fire. Flossie Bailey married a local rancher named Hamlin and raised a family.

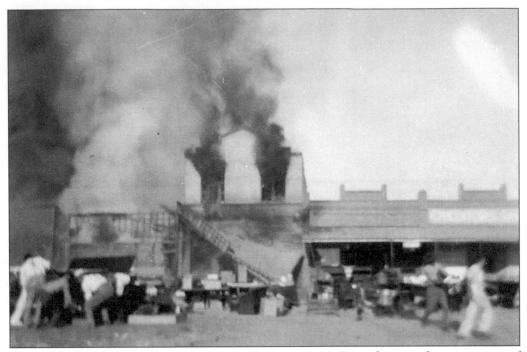

The fire began at 6 a.m. on the morning of August 7, 1915, resulting in the renovation of the east side of Main Street. This photograph shows the progress of the fire as it moves through the businesses.

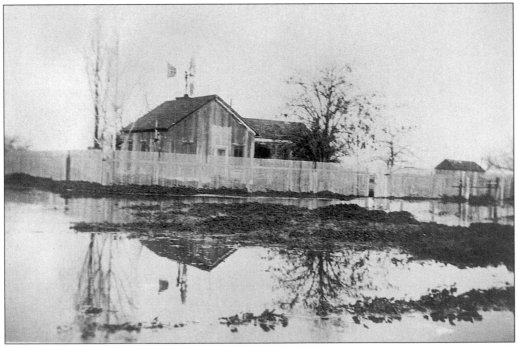

The White River is located north of Delano, and in years when rainfall is above normal, it floods. In 1910 the river overflowed its banks rushing into the yard of the Kramer homestead. In Earlimart, the water often rolled over the bank and flowed into the streets.

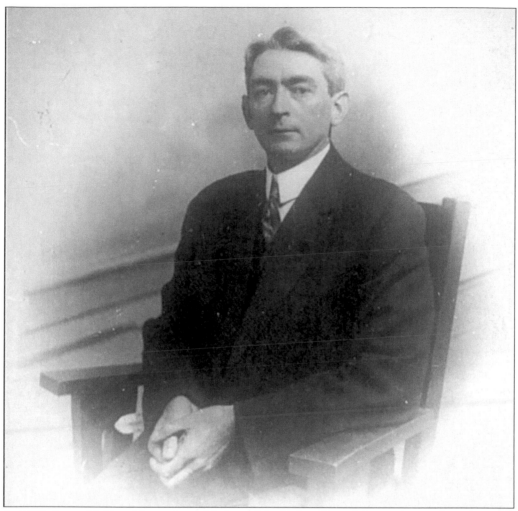

In 1898, James McDonald was the publisher of the *Delano Record*. It is unknown how long the *Record* continued its publications before the first issue of the *Delano Holograph* appeared on May 29, 1908. The *Delano Record* was revised in 1908 and continued to covered the fires and floods of the area.

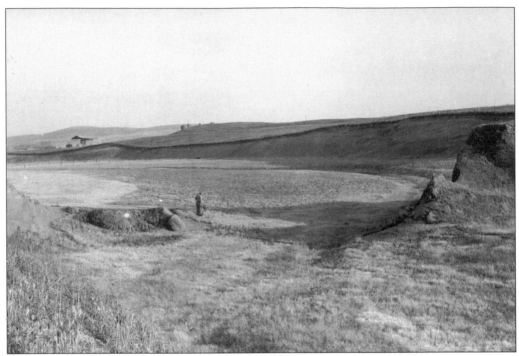

Inspired by the Spangler brothers' irrigation schemes for the area, the Quinn Dam site on Rag Gulch was an asset for dry land farming. In heavy rainy seasons, the dam could not hold back the heavy flow of water from the foothills and broke, sending torrents of water into the outlying areas. This picture shows the large break in the dirt dam.

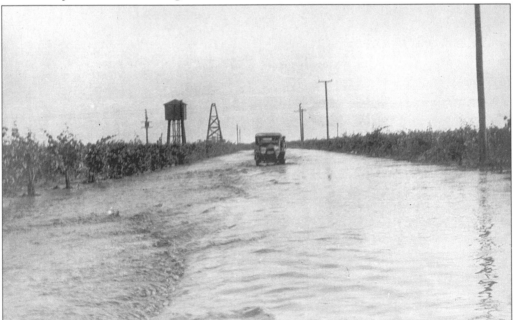

Driver Road, located east of Delano, is pictured here on April 9, 1926. Water from the broken Quinn Dam poured over the roads, rushing into the grape vineyards flooding the rows making it impossible to get to the fields for weeks.

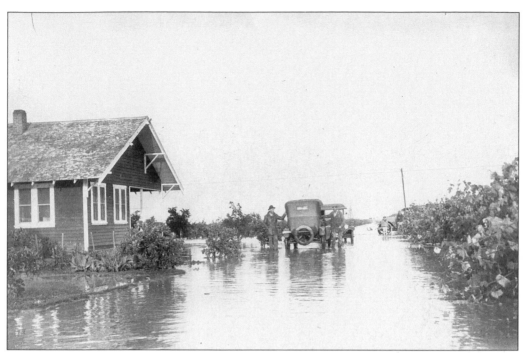

Local farmers and ranchers woke one morning in 1926 to find their homes and stockyards covered with flowing water from the Quinn Dam, which had failed to hold back the water from a cloud burst.

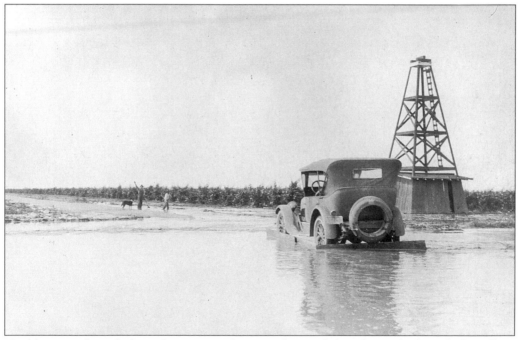

Unable to get through the rushing water, these ranchers and their dog wade through the rolling water to check the damage done to their land and crops. The farmer's car sits in water up to the running board.

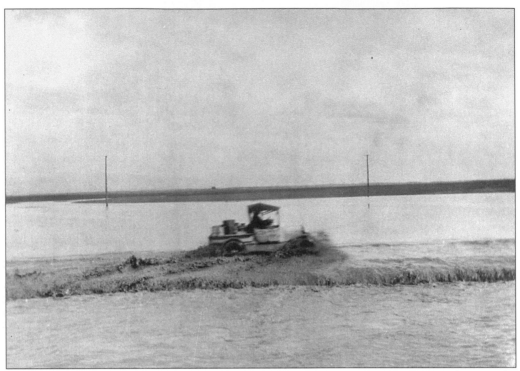

This picture of Rag Gulch at old Highway 65 and County Line Road was taken as the floodwaters piled up 18' deep against the railroad track. Rag Gulch has overflowed on numerous occasions since 1926, but this was the first recorded flood.

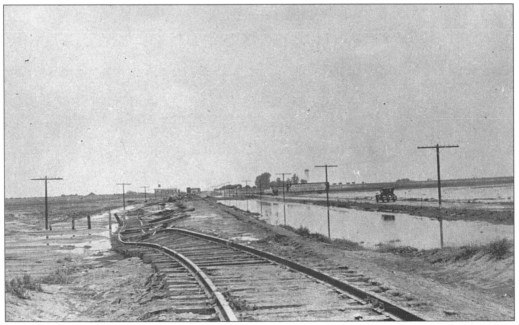

This was the scene after the railroad bed gave way under the pressure from the building floodwater. The rails were shoved and twisted as the water undermined the rail beds. The small settlement of Richgrove is visible in the foreground.

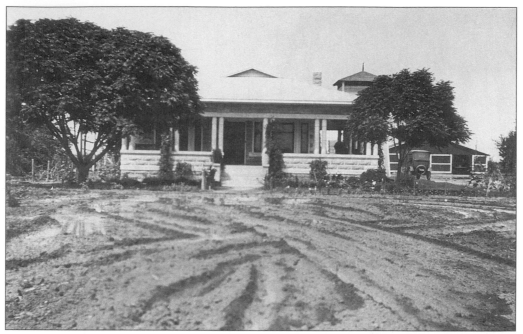

Nora Dyar stood on the porch of her home on April 30, 1926, and surveyed the damage done to her land as the water from the flood receded. Even after several weeks, water still stood on the spring-plowed ground.

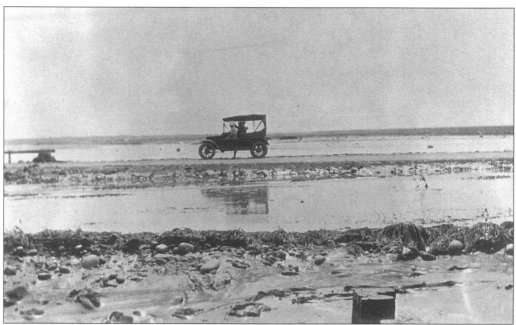

The mud and water was evident for weeks after Quinn Dam belched its stored water onto the surrounding area. Roads were like islands, with mud and water lining the shoulders of the paved roads.

On April 13, 1915, Harvey Hawley was elected to Delano's first city council at a time when the city was gaining momentum in Kern County. He was also president of the First National Bank in Delano.

After extensive efforts by the citizens to establish a city government, L.B. Crow was elected mayor of the City of Delano. He found that he was facing a number of challenges since the city had to deal with both Kern County and bordering Tulare County.

D.L. Cole accepted an elected position on Delano's first city council, which aimed to establish a workable city government. Mr. Cole was involved in the farming and ranching business in the area and could bring this knowledge into play as Delano was influenced by farming interest.

103

F.E. Hare became an elected member of the first city council after the incorporation of Delano. The city's first attempt at incorporation in 1910 failed. Hare realized Delano's unique situation, being located at the northern end of the county.

Phillpe Girard, a noted member of one of Delano's pioneering families, served on the first city council after the fire of 1915. The struggle to rebuild a major part of Main Street was evident, and the strengthening of the new city government was a challenge to be met.

Eight

NEIGHBORING
COMMUNITIES

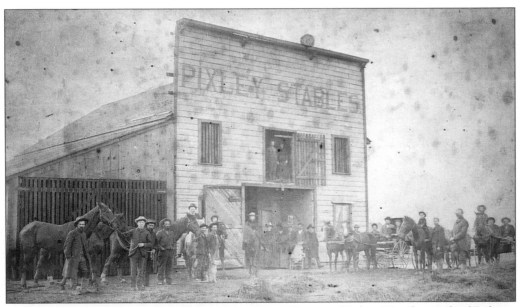

This photo of the Pixley Stables, facing east on Front Street in Pixley, 16 miles north of Delano, was taken during the late 1800s. It was one mile south of this location that the Dalton brothers were involved in a train robbery near Alila.

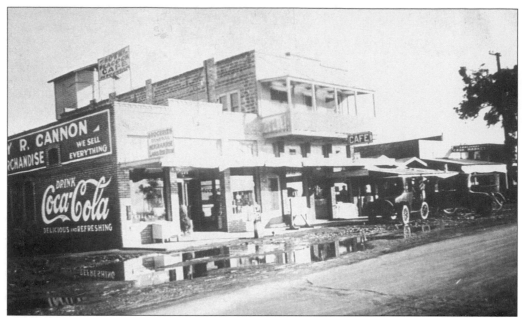

In this view of Earlimart's Front Street in 1927, a mercantile store and a cafe line the street. There were living quarters above the cafe. In the beginning, the town was called Early Market, as local farmers brought produce to the area for shipment, and was later changed to Earlimart.

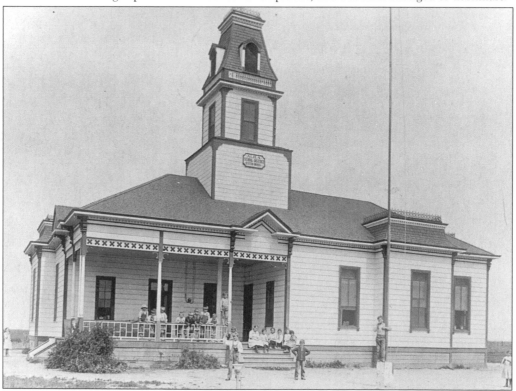

After a fire in the spring of 1892 destroyed the first Earlimart School, a temporary school was used until 1919, when the new Alila School was constructed at the edge of town.

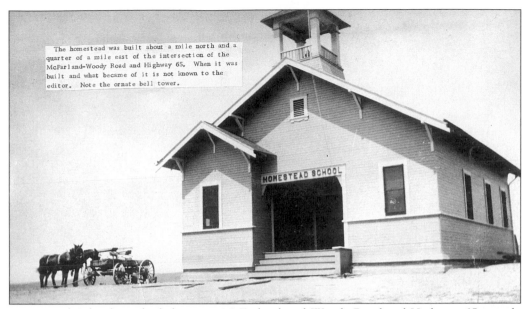

Homestead School was built between McFarland and Woody Road and Highway 65, a mile north and a quarter mile east of the intersection, to educate local farm and ranch children. Note the ornate bell tower. No one knows what happened to the building.

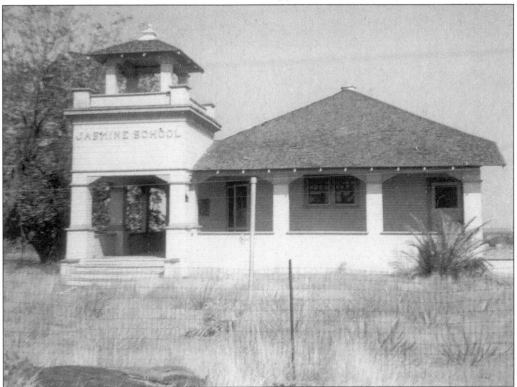

In 1916, Jasmine School was built eight miles southeast of Delano on Rich Avenue to serve the small farming area of Jasmine. The highest number of pupils ever to attend Jasmine was 19 in 1919.

Famosa, located 12 miles south of Delano, had a number of fruit-picker camps during the 1930s. Midwesterners migrated to the area to work in the orchards to support and sustain their families.

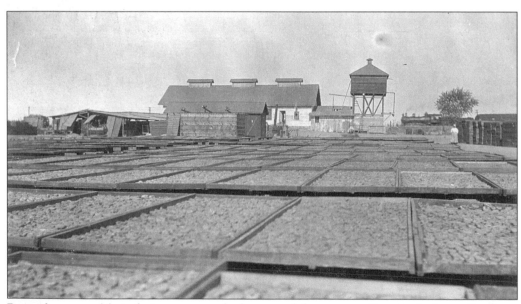

Row after row of fruit-drying trays catch the rays of the sun at a Famosa shed as a Southern Pacific Train rolls past at the back of the yard. The town of Famosa is located at the Highway 46 and Highway 99 Junction 12 miles south of Delano.

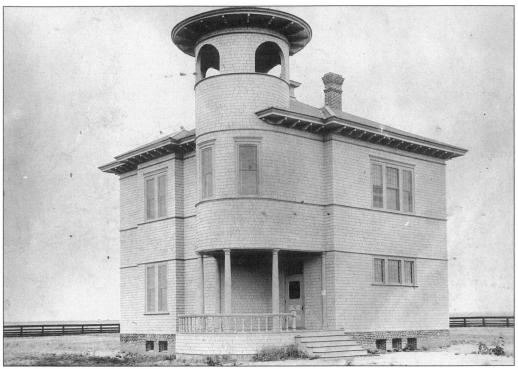

The Robertson school was built in 1888 and later replaced by the Richland School, located two miles north of Famosa at the corner of Driver and Phillips Avenue. It featured a unique bell tower atop the two-story wooden structure.

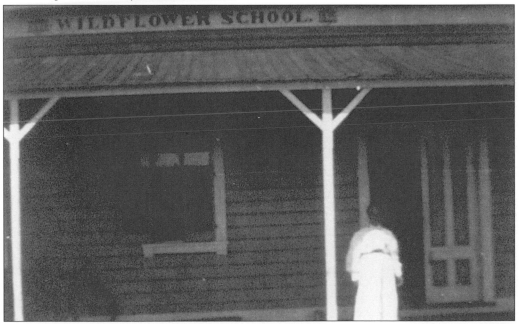

Tulare County's Wildflower School building was constructed on the northwest corner of Road 184 and Avenue 24, between Delano and Earlimart. This photograph was taken about 1920. Fire destroyed the school in the early 1960s.

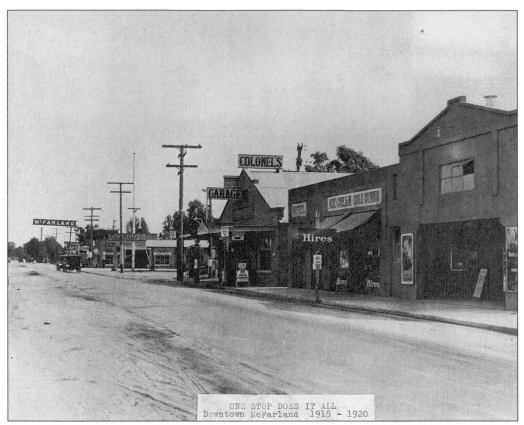

Pictured here is downtown McFarland, sometime between 1915 and 1920. Old Highway 99 was the town's main street, with a service station, garage, hotel, and grocery store for the convenience of those seeking a cool drink on a hot summer day.

The original McFarland High School, built in the 1920s, served the students of the community until the earthquake of 1952, after which a large portion of the structure was torn down and replaced with an updated building.

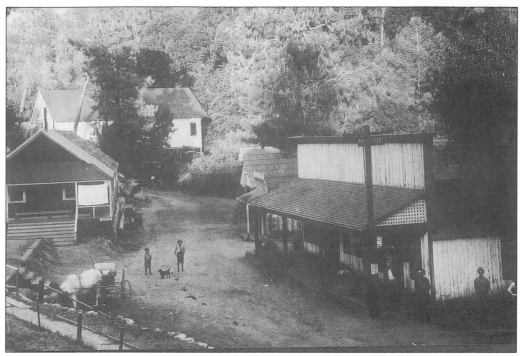

The mountain community of California Hot Springs, east of Delano on White River, afforded relaxation and entertainment for many Delano residents who dared to venture the mountain roads. This is a photograph of the bathhouse and store in 1907.

Laura Stuhr Triplette and her students pose for a school picture in 1922–23 in front of the Richgrove School, which is located six miles east of Delano off Highway 65.

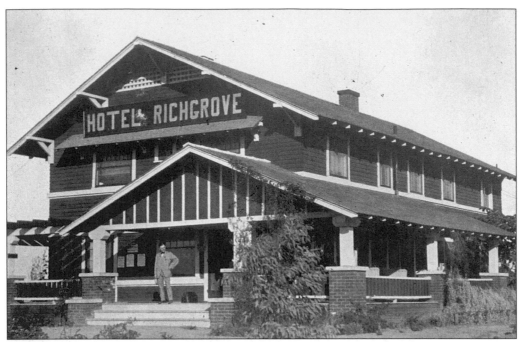

Built in 1909 as Richgrove's first structure, the Richgrove Hotel housed local residents as well as travelers. This photograph was taken in 1920, and the building is still in use today.

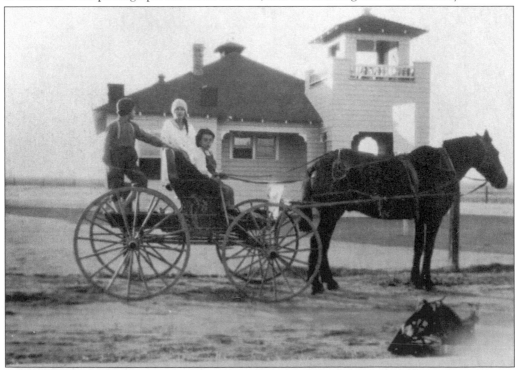

Similar in design to the Jasmine School, the Weston School was located at Avenue 56 and Road 168, east of Earlimart. Lucien Escalle, Norma Porter, and Frank Escalle pose with their horse and buggy about 1920.

Mr. and Mrs. John Cramer lived in a farming community northeast of Delano known as Columbine District. This photograph of the Cramer farm was taken in 1913.

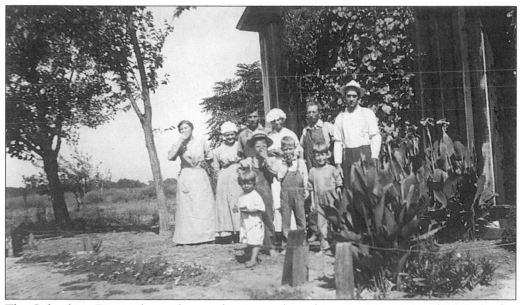

The Columbine District boasted many farming and ranching operations around 1913. In this photograph, the Miller family stands in front of their home.

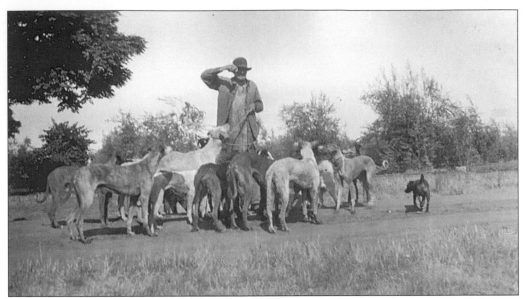

During the early 1900s, it was not unusual to see a man in the countryside near White River working his hounds. Dogs were an important tool for local ranchers and farmers. They hunted, herded cattle and sheep, and acted as the family burglar alarm.

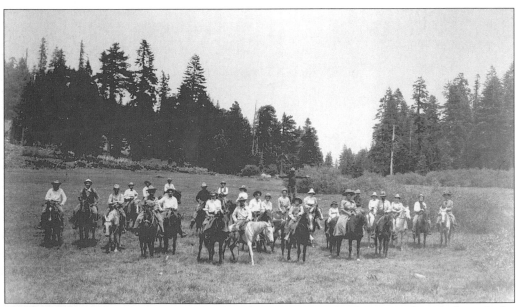

Pine Meadow was a gathering point for the adventurous people who enjoyed a ride through the rugged mountainous area above Delano. This photograph of a riding party was taken in the early 1900s.

Nine
RECREATION

The pioneering Cecil family donated this land to the City of Delano to be used as a public park. Should the terms of the contract be altered, the land will revert back to the Cecil Estate. This photograph dates from 1911.

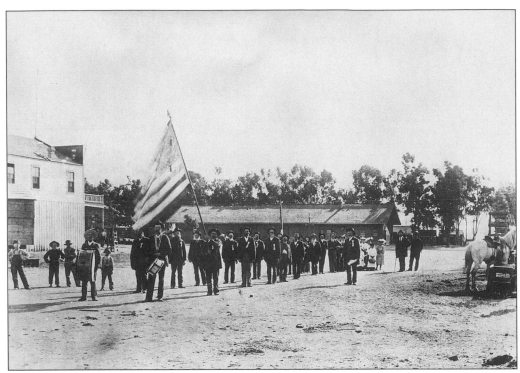

On Memorial Day in 1890, the Delano Grand Army of the Republic paraded through town for local citizens. The photograph was taken in front of the Southern Pacific Railroad Depot and shows the Davis Drug Store off to the left.

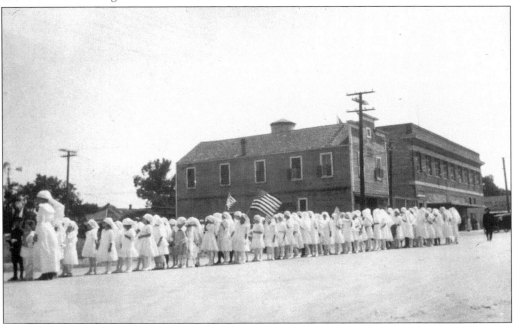

Parades were a favorite event for the area. The 1916–18 Red Cross marched down Eleventh Avenue and Main Street. The tradition of parades is still practiced in Delano and neighboring communities.

JEDEDIAH JUDKINS.

This Popular Drama will be presented at

WEAVERS HALL

—ON—

SATURDAY EVENING, MARCH 20.

—BY—*1896 or 1897*

LOCAL TALENT.

CHARACTERS:

Jedediah Judkins, Justice of the Peace...............**W. S. Winter.**
John Craincross, a TradesmanRay E. Turner.
Herbert Craincross, John's son, an EngraverR. Elwood.
Reginald Windum, Senior partner in the firm of Windum &
Tick, Jewelers ..Will Perrin.
George Prentiss, a DetectiveJas. A. Tandrow.
Horatio DeCamp, a Crook...............................C. E. DeWitt.
Buck Hardin, the other one of the pair.....................Jos. Tandrow.
A Policeman—Officer at Police StationFrank Porter.
Mrs. Craincross, John's wifeMrs. F. B. Lardner.
Bernice Craincross, the DaughterZoe Timmons.
Esther Goldfair, John's ward**Mrs. C. E. DeWitt.**
Miss Bobin, nobody knows whatMiss Eva Timmons.
Sally Sands, a silly servant to the Craincrosses.......Mrs. A. M. Woosley.

SYNOPSIS:

ACT. I. Jedediah, a Hoosier farmer, comes to the city as a delegate to a convention. Takes up his abode with the Craincrosses. News of the robbery of Windum & Tick's jewelry store. Herbert, the engraver, suspected. DeCamp gets the lay of the land, and Hardin visits the house of the Craincrosses uninvited. The American eagle meets the British lion.

ACT II. Prentiss, as a book agent, displays some skill in the use of the English language. Jedediah signs a doubtful petition. Herbert arrested for forgery and burglary.

ACT III. In the police station. Two upon one, and he handcuffed. Jedediah, in spite of his position, lends a hand. The keeper shot. A scene in the home of the Craincrosses.

ACT IV. In a miner's cabin. Familiar characters in unfamiliar dress. Crackey makes a crack shot. "The Redskins! The Redskins!" At the home of the Craincrosses. The return. Happy termination.

Admission 25 Cents. Reserved Seats. 30 Cts.

This program was issued by the local Dramatic Club for the production of "Jedediah Judkins" in about 1900. Most of the events were held at the Weaver's Hall, located on the second story of the hardware store at Twelfth Avenue and High Street.

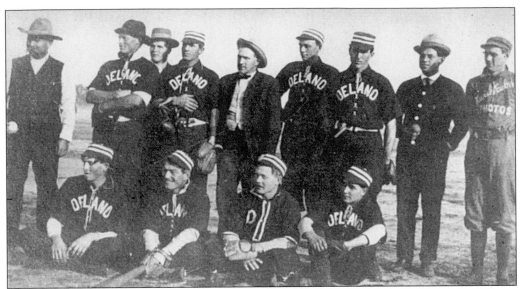

Delano's first organized baseball team is pictured in October 1908, from left to right, as follows: (seated) George Granger, G.G. Newell, Adley Sherwood, and Ed Valencia; (standing) Lou Crowe, Earl Wolfe, Tommy Semley, Everett Timmons, Tom Tobertson, Manager Oscar Pitt, Earl Dyar, Frank Cuevas, and Jimmy Stockton.

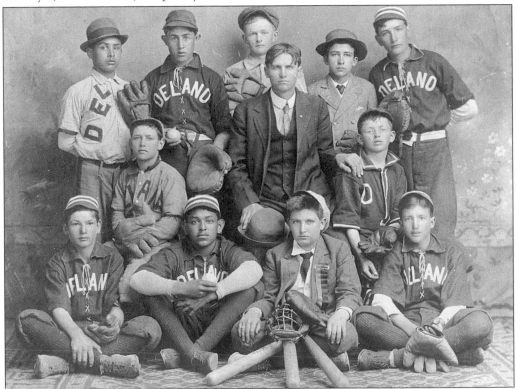

Pictured in 1920, Delano's championship baseball team is, from left to right, as follows: (standing) Steve Nunez, Ernest Borel, Harvey Sherwood, Stockton, Byrne, J. Panero, Giluran Miller, Lynn Bower, Woosley, Joe Nunez, Perry Stewart, and Morris Roberts.

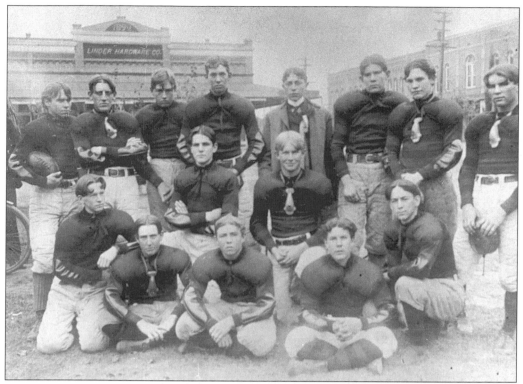

On November 28, 1902, local citizens traveled to a neighboring community to see their local hometown boy play football in the game between Tulare and Porterville. Pictured fourth from the left is Charles Dorsey, the son of a local pioneering family.

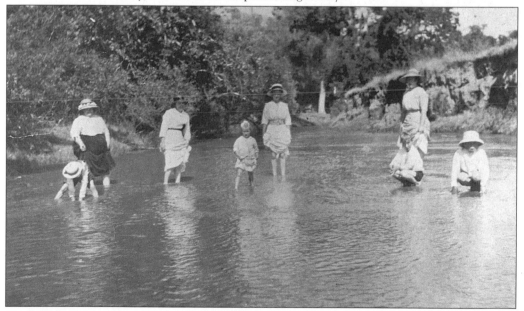

Cecil Dyar, Jessie Starr, Edythe Burkett, Edna Scott, Bessie Scott, Cletus Dyar, Nora Dyar, and Leland Scott wade in the cooling waters of the White River above Salsa Ranch on an outing in 1918.

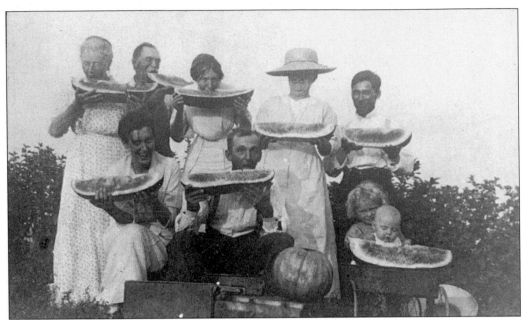

A favorite summer pastime was enjoying the fruits of one's labor. Around the 1920s–1930s, watermelon feeds were a common occurrence among farm families. When harvest time was over, neighbors gathered for a celebration.

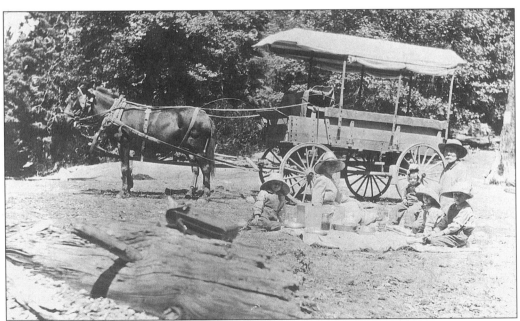

Vacations were a great adventure for the family. Many local families hitched up the buckboard and mules and headed to Cedar Creek in the mountains above Delano. In this 1911 photograph, Leland Scott, Mrs. George Scott, Edna Scott Steward, Cecil Dyar, George Scott, and Cletus Dyar loaded up the wagon and headed out.

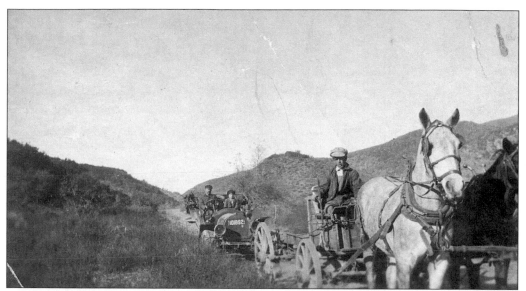

In 1914, Allie Escalle and her son Lucien headed in their car over the Ridge Route (near Saugus) for Los Angeles, the nearest large city offering the ultimate shopping experience.

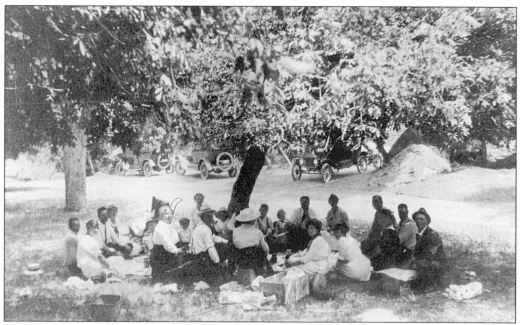

In 1919, Coffee Camp (above Springville) was a frequented picnic spot for families wishing to get away from it all. The Scott family often visited the area for family outings.

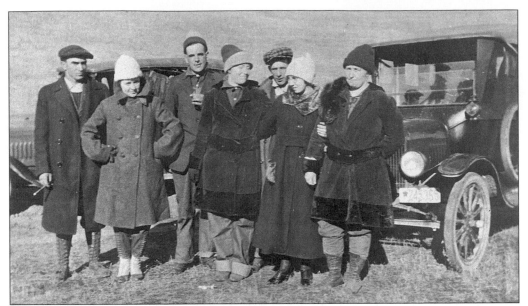

Winters in Delano were not severe, therefore it was not unusual for a snow party such as this one in 1920 to be planned. Earl Dyar, Arla Wallace, John Cramer, and Violet Cramer stand beside their car on Woody Road before heading for the snow.

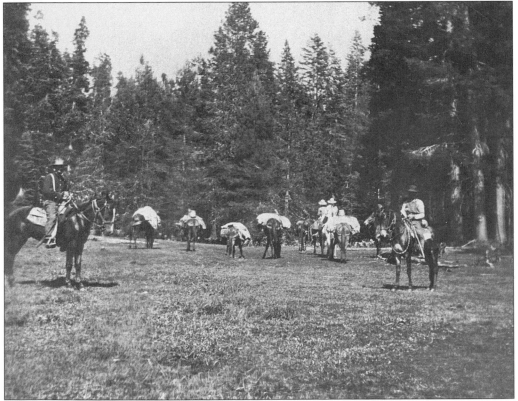

Citizens of the area often organized a pack train to Kern Flats. In June 1910, Dooley and Earl Dyar took friends and headed for the hills, hoping to get back to raw nature.

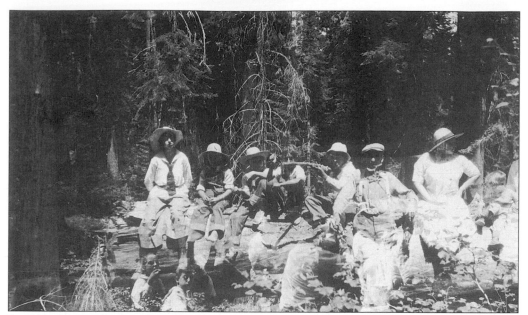

In 1920, Sequoia Park was another favorite spot to visit among local residents. This photograph shows a number of Delano pioneers roughing it in the redwoods.

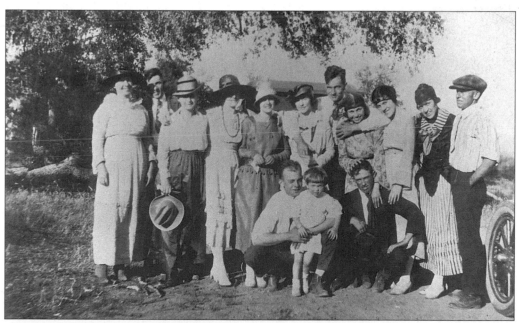

Sundays after church, locals gathered for automobile rides through the countryside. Maude Cook, Ward Robertson, Maude Fairservice, Julia Flanagan, Angele Borel, Georgia Williams, "Doc" Cook, Verna Bowhay, Rettie Robinson, Ellen Bowhay, Morris Bowhay, Lawrence Hileman, Dorothy Cook, and Arch Quinn pose before leaving.

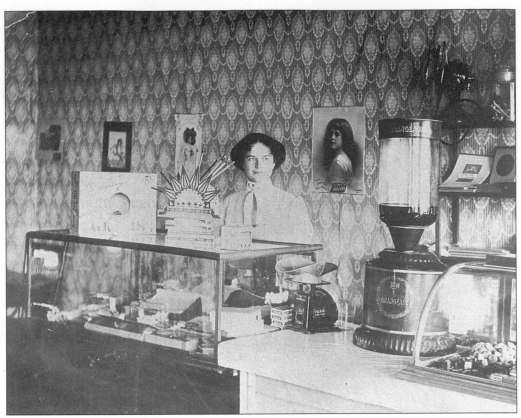

Between 1906 and 1915, a favorite hangout in Delano was the Bon Bon Shop and Ice Cream Parlor owned and operated by Flossie Bailey. The shop located on Main Street was destroyed in the fire of 1915.

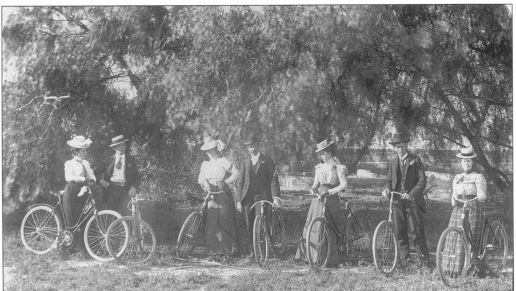

Biking and picnics were all the rage in the 1900s. Nell Bullock, Jim Willis, Mrs. Frank Schlitz, Frank Schlitz, Rachel Hobart, Guy Turner, and Ethel Weaver pose beside their bikes.

Dan Cornwell drives the wagon and horses owned by E.E. Timmons down Main Street and Eleventh Avenue in 1912. Buggy rides, horses, and wagon rides helped one deal with the stresses of life for the pioneer family.

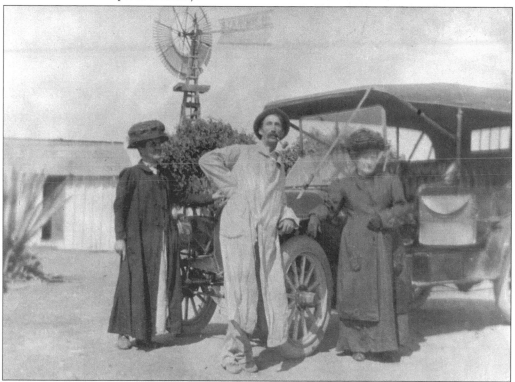

Aunt Bert, H.P. Burum, and Granny Burum don their Sunday best for a ride in the old Mitchell car in 1913. The Burum Family owned and operated a farming business northeast of Delano.

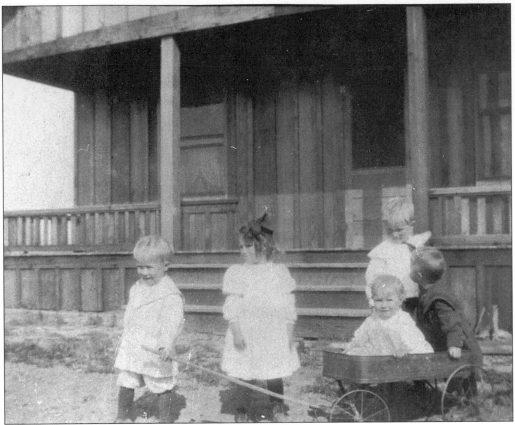

Children were the mainstay of the family, gifted with the talent to entertain themselves. This 1910 photograph captures a number of children playing with a wagon on the Quinn Ranch.

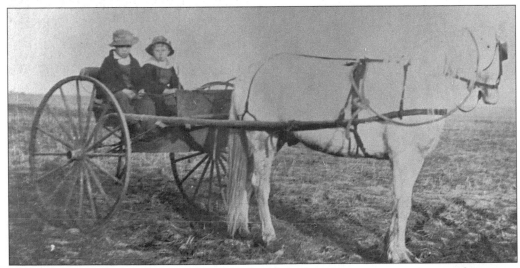

Children of the pioneers endeavored to keep busy by either playing games or buggy riding across the countryside. Here, the Dyar children head to school with a favorite horse pulling their cart.

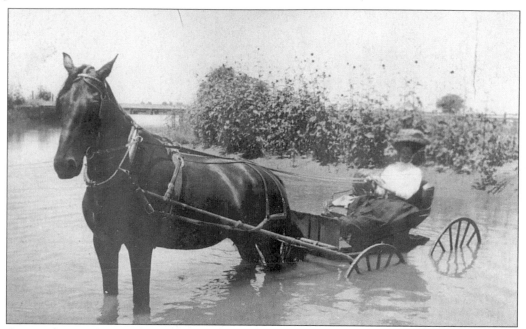

Cutting loose is not without its hazards. In 1905, Anna Bell Robertson found herself in the middle of Calloway Canal, urging her horse to cross to the opposite bank.

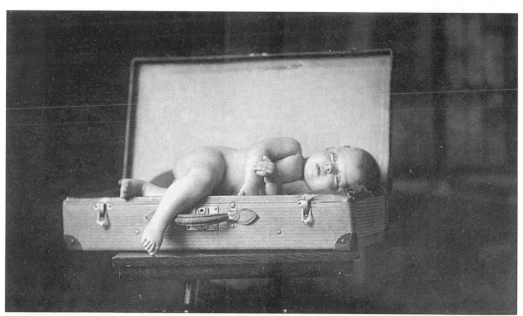

Recreation has different meaning for us all. Loring Coowin Miller found relief from the day's play by lying in an open suitcase half asleep. The child was four and a half months old in 1910.

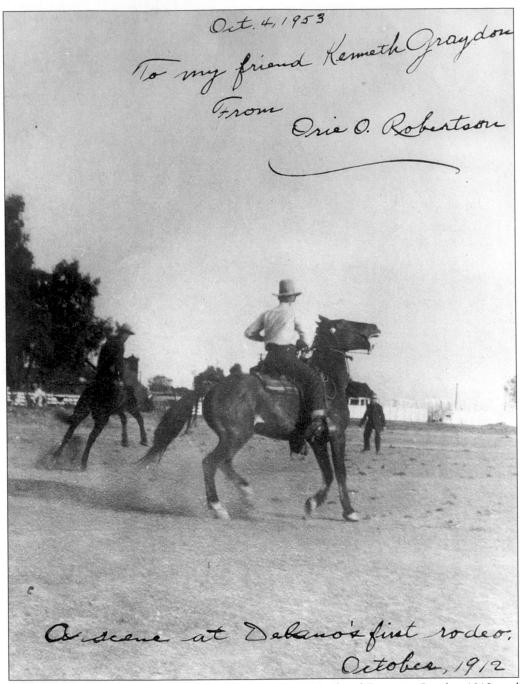

Oct. 4, 1953
To my friend Kenneth Graydon
From Orie O. Robertson

A scene at Delano's first rodeo,
October, 1912

Delano's first rodeo took place near the Southern Pacific Railroad Depot in October 1912, and this image is believed to be the only photograph taken of the event. The horsemen, Loyd Hamlin and Orie Robertson, were participants. Rodeos became an annual event in the area.